IMAGES
of America

HARTFORD

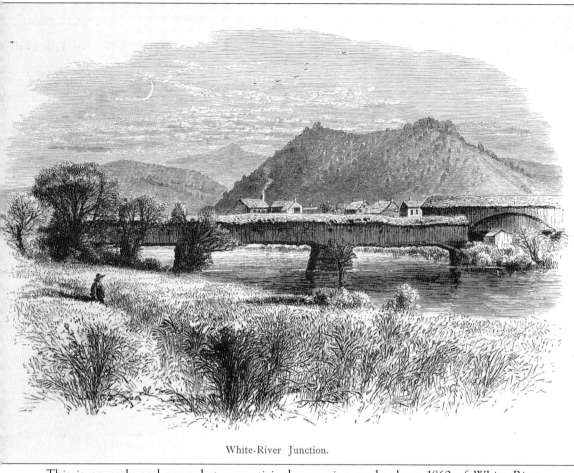

White-River Junction.

This is an early and somewhat romanticized engraving made about 1860 of White River Junction, looking across the Connecticut River from New Hampshire. In the foreground is the Lyman Bridge, and in the distance is the first bridge across the White River for the Connecticut and Passumpsic Rivers Railroad. Beyond is the railroad village of White River Junction. (Author's collection.)

On the cover: It appears lost to history what these five men, one in an underwater diver's outfit, are doing out on the Connecticut River in a small raft in front of the large International Paper Company mills located at Wilder Village. This photograph was probably taken about 1910. (Courtesy Hartford Historical Society.)

IMAGES
of America

HARTFORD

Frank J. Barrett Jr.

ARCADIA
PUBLISHING

Copyright © 2009 by Frank J. Barrett Jr.
ISBN 978-0-7385-6366-4

Published by Arcadia Publishing
Charleston SC, Chicago IL, Portsmouth NH, San Francisco CA

Printed in the United States of America

Library of Congress Control Number: 2008936833

For all general information contact Arcadia Publishing at:
Telephone 843-853-2070
Fax 843-853-0044
E-mail sales@arcadiapublishing.com
For customer service and orders:
Toll-Free 1-888-313-2665

Visit us on the Internet at www.arcadiapublishing.com

CONTENTS

ACKNOWLEDGMENTS

Since the earliest days of photography, various events and areas of Hartford have captured the photographer's eye. And more recently, historians have been fortunate that much of this recorded imagery has been collected and now safely resides within the following archives.

First, the Hartford Historical Society was very generous, making its extensive archives and collections fully available for use with this project. The Woodstock Historical Society was likewise very helpful with a number of key images to help tell the story of this unique and diverse community.

The Vermont Historical Society opened its rich archives and further helped to fill in some key elements of the story. And as with many past projects, the cheerful staff at Dartmouth College Special Collections was of tremendous assistance.

To the above and others, I am thankful for your interest and help with this book. After spending time viewing your fabulous collections, my only regret is that space considerations dictated that I was unable to feature more of your fine historical images.

INTRODUCTION

Until the waning days of the long struggle between the French and English for control of North America, terminating with the English conquest of French Canada in 1760, settlement of the Upper Connecticut River valley, western New Hampshire, and all of present-day Vermont was not a viable or safe option. However, during the years of the French and Indian Wars of the 1750s, the continual passing of troops from lower New England through this region caused the value of these lands to become recognized and, as a result, widely known.

In March 1761, under the direction of the royal governor of New Hampshire Benning Wentworth, Joseph Blanchard, a surveyor from Dunstable, New Hampshire, set out from Fort No. 4 in Charlestown, at that time the most northerly point of any settlement within the Connecticut River valley. Traveling on the still-frozen ice and ground along the river's bank, he headed north about 60 miles to the mouth of the Wells River, marking and numbering at six-mile intervals on each side of the great stream what would soon become the corners of future townships. On the Fourth of July that year, Wentworth, officiating from the Colonial capital of Portsmouth, New Hampshire, issued five new town charters of what would be the first of more then 140 towns granted by him in these western regions—112 of them located west of the Connecticut River in what is now the state of Vermont. Prior to the July 20, 1764, decree by King George III that finally established the Connecticut River as the official boundary between the king's colonies of New Hampshire and New York, Wentworth considered all the territory now known as Vermont as legitimately part of Colonial New Hampshire.

On July 4, 1761, the town of Hartford, along with the sister towns of Norwich, Hanover, Lebanon, and Enfield, came to be, the first of the often-referred-to "middle grants." Born under the reign and guidance of the world's most powerful monarch, King George III of Great Britain, created by Wentworth, his perhaps most colorful of all royal governors, and initially part of His Majesty's Royal Colony of New Hampshire, the town of Hartford began its unique and varied journey forward into the New World. Perhaps this is best summarized by the opening statement of the lengthy charter document signed by Wentworth that reads, "Province of New Hampshire. George the Third, by the Grace of God, of Great Britain, France and Ireland, King, Defender of the Faith, etc. To all persons to whom these presents shall come. Greetings."

The opening of vast, new wilderness sections of land for permanent settlement necessitated teams of land surveyors to further the initial work begun by Joseph Blanchard. Two brothers, Elijah and Benajah Strong, from the Lebanon, Connecticut, area, were by vocation land surveyors and as a result among the first to perambulate the proposed new township that became Hartford. Upon their return, they spoke impressively to their neighbors in and around Windham and

Lebanon, Connecticut, of the splendid waterpower and potential mill sites discovered by them on the three rivers that water the township, of the valuable and expansive white pine forests situated adjacent to these great streams, and of the many broad, fertile terraces of potentially tillable land.

These reports hastened John Baldwin of Windham and 61 other grantees from the Windham and Lebanon, Connecticut, area to secure what was the first of five charters issued that day in July 1761 by Wentworth. The name Hartford was undoubtedly chosen by virtue of the grantees residing in the colony of Connecticut, of which Hartford, in Hartford County, was the capital. During the mid-1760s, as matters were being sorted out with New York concerning towns chartered by Wentworth west of the Connecticut River, an early map titled *Chorographical Map of the Northern Department of Northern America* showed Hartford as "Ware," located within Cumberland County, New York.

During the summer of 1761, the first inspection of the new township was made by an appointed committee of grantees, and upon their return to Windham, Connecticut, in November, the first of many divisions and assignments of lots took place. Also at that time, Baldwin was paid a sum of money for his efforts at securing this prized charter—they believed the best in the valley.

The next year, groups of men began surveying and clearing areas of land during the summer months, then returned to lower Connecticut for the winter. In the spring of 1763, Benjamin Wright became the first permanent resident to settle in Hartford. It is believed that he erected the first house in town at or just below the mouth of the White River, positioned slightly back from the Connecticut River. By the following year, Elijah, Solomon, and Benajah Strong; Jonathan Marsh; and Noah Dewey, together with their families, were also permanently located in Hartford, having traveled up the river from lower Connecticut. Within the years to immediately follow, many more made that same arduous journey and called Hartford their new home.

Since my earliest years growing up in the Upper Connecticut River valley, I have long been interested in the history of the Hartford area. The sight of the railroads in and around White River Junction while my mother shopped in the J. J. Newbury store was spellbinding to a small boy. The ride with my parents along the White River valley on Vermont Route 14, passing by the various buildings and rolling pastoral farms, was always welcomed. Slightly later, beginning to learn the history of the vanished Woodstock Railway and the mills that were closing, or being in my older brother's boat on the Connecticut River near Wilder fueled my interest in what I soon came to realize is the most diverse and unique of all the communities within this area of the Upper Connecticut River valley.

This book does not pretend to be a complete history of the town of Hartford, as others before me have already done a superb job of that. Rather, this is just one person's desire to photographically share slices of local Hartford history, primarily looking at the built environment that continues to be a lifelong fascination to me. It is my sincere hope that you will enjoy reading this as much as I did in putting it together.

One

SETTLEMENT AND HARTFORD VILLAGE

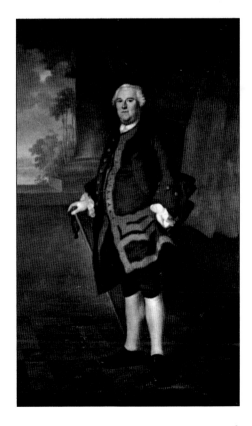

Benning Wentworth (1696–1770) served as New Hampshire's royal governor from 1741 to 1766, when he was removed by King George III. Until 1764, when told otherwise by the king, Wentworth considered all of present-day Vermont as part of Colonial New Hampshire—not New York. Toward that end, between 1761 and 1764, 111 towns were granted west of the Connecticut River, including Hartford, established on July 4, 1761, the same day as neighboring Lebanon, Enfield, Hanover, and Norwich. (Courtesy Dartmouth College Special Collections.)

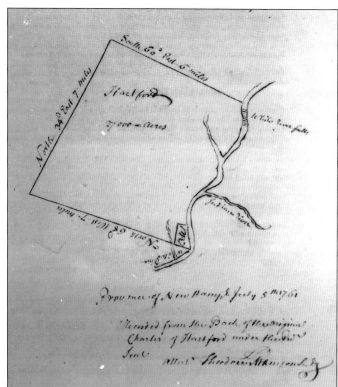

Each town established by Benning Wentworth included a map with the standard written charter. The first map of Hartford shows a typical six-mile-square township of 27,000 acres, with a 500-acre parcel reserved for the governor marked "B.W." Note the mention of the White River Falls on the Connecticut River, the White River is not named, and the Mascoma River is called "Indian River." Mention is made of "White Pines" in the southeast corner, but there is no name for the Ottauquechee River. (Courtesy Hartford Historical Society.)

There appears to be little doubt that Benjamin Wright from Connecticut was the first person to permanently settle within the town of Hartford in 1763. What is not clear is if his first cabin was here at the mouth of the White River or just south of this point along the bank of the Connecticut River. This view from about 1860 shows the intersection of the two rivers looking from Lebanon, New Hampshire. (Courtesy Vermont Historical Society.)

Although originally not one of the first settlers of Hartford, by about 1791, 23-year-old Elias Lyman III settled in Hartford and soon acquired large amounts of land at the mouth of the White and Connecticut Rivers. He quickly became wealthy from merchandising and handling freight on the Connecticut River. By 1796, he erected this home on the northwest corner of present-day Pine and Maple Streets. (Courtesy Hartford Historical Society.)

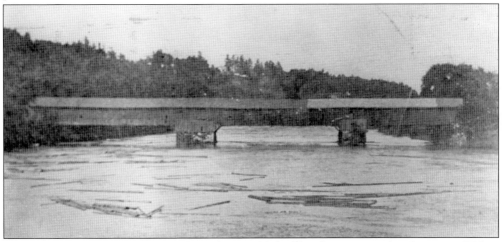

In 1800, Elias Lyman III secured the rights established by the Vermont legislature in 1795 to construct a toll bridge crossing the Connecticut River between Hartford and Lebanon at the present location of the U.S. Route 4 bridge. An open, wooden, three-span structure was soon erected, the predecessor of the covered bridge seen here, which was built as a replacement in 1836 and stood until again replaced in 1895. This undated view of the Lyman Bridge looks upriver. (Courtesy Hartford Historical Society.)

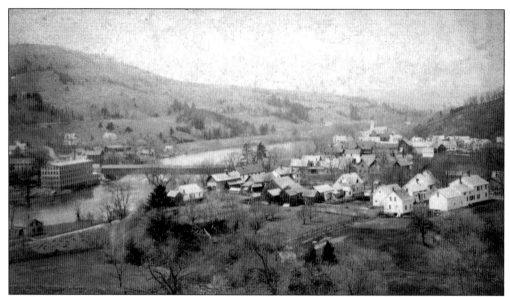

Hartford Village began with the first mills constructed in 1795, which took advantage of waterpower resulting from a slight drop in elevation of the White River at that location. In fact, early in the 19th century, the settlement was known as White River Village well before the coming of the railroads and the subsequent establishment of nearby White River Junction. (Courtesy Hartford Historical Society.)

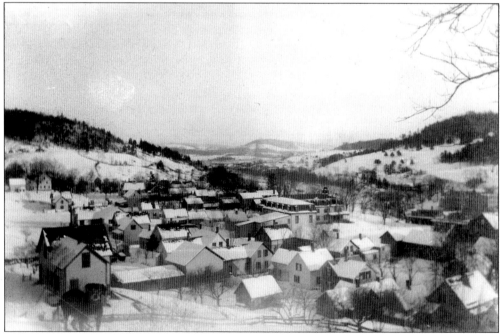

In addition to waterpower, the location of Hartford Village provided a flat plateau on the north bank elevated above the White River, which was conducive for settlement and a suitable location for a bridge crossing. With the relocation of the town clerk and meetinghouse from the early center of town area to this growing village community, by 1840, Hartford Village became the central point of town government. (Courtesy Hartford Historical Society.)

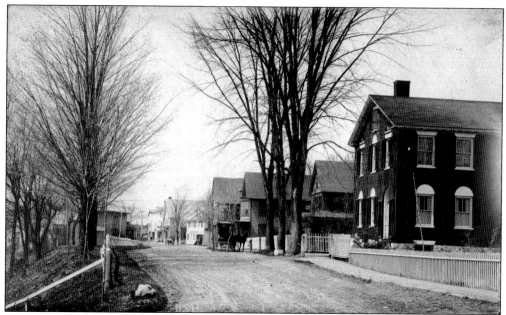

Throughout the 19th century, Hartford Village grew and prospered due in part to the mills located along the river and its relationship with transportation within the White River valley. The first post office established in all of Hartford was located within this village area in July 1806. By the spring of 1887, the village of almost 500 inhabitants boasted of five well-established merchants' stores. (Courtesy Hartford Historical Society.)

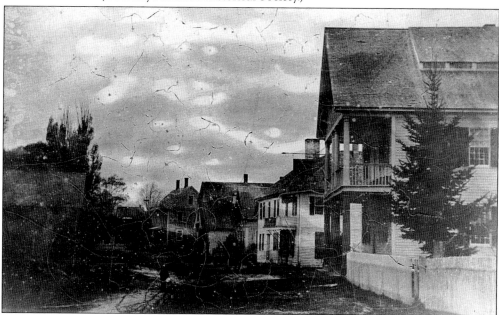

The White River Turnpike Company received its franchise from the Vermont legislature on November 1, 1800. Soon thereafter, a toll road was constructed, about 21 miles in length, from Lyman Bridge at the Connecticut River, through Hartford village, and along the north bank of the White River to the mouth of the second branch in Royalton. This early view looks west along Main Street. To the immediate right is the Pease Hotel. (Courtesy Hartford Historical Society.)

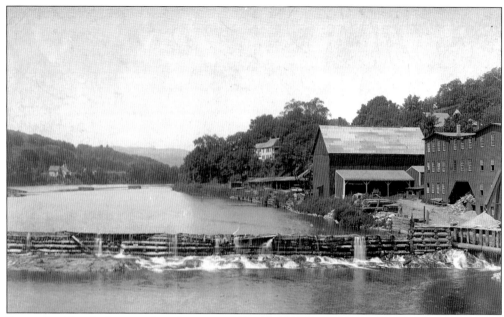

Soon after Hartford received its charter in 1761, the first lots were surveyed and conveyed along the White River adjacent to potential waterpower. However, it was not until 1795 that Jacob Murdock began construction of the first dam and erected a gristmill and sawmill on the north side. This view from about 1900 shows a dam across the river's ledges, with a chair factory and an icehouse beyond. (Courtesy Hartford Historical Society.)

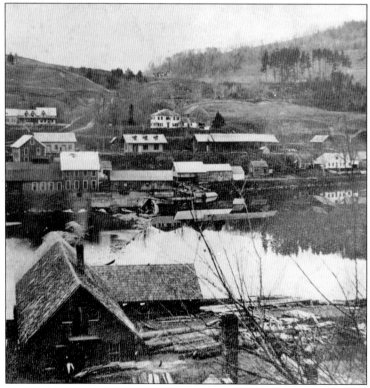

Mills were established on the north side of the White River at Hartford Village almost as early as they were on the south bank. This view from about 1870 shows the farm implement factory of French, Watson and Company. Toward the upper middle are the Central Vermont Railway's passenger station and freight house buildings. The square white building with the hipped roof is Edwin Watson's residence, one of the farm implement company owners. (Courtesy Hartford Historical Society.)

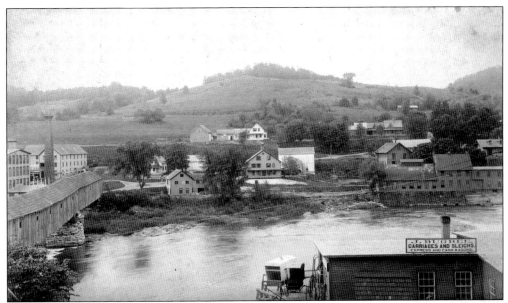

By 1807, small fulling and carding woolen mills had been constructed along the south bank of the White River adjacent to the bridge crossing. The following year, a sawmill joined the lineup, the second one in Hartford Village. By 1880, about when this photograph was taken, those early mill buildings had long since disappeared, the victims of floods, fires, and age. (Courtesy Vermont Historical Society.)

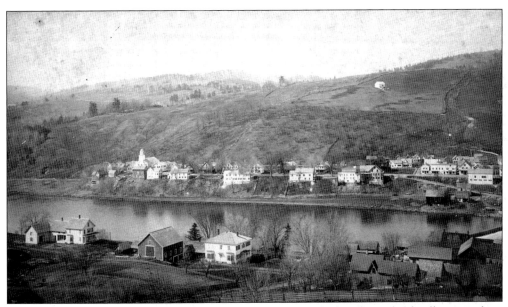

This 1880s view looking north at the west end of Hartford Village clearly illustrates how settlement spread out along a narrow shelf of land elevated above the White River while some buildings clung to the edge of the riverbank. Behind the structures are upland pasture areas, primarily used for sheep grazing. (Courtesy Vermont Historical Society.)

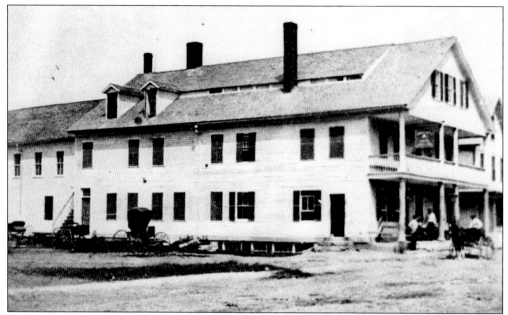

Asa Richardson established the first hotel in Hartford Village in 1801, in part to take advantage of travel on the important and busy newly opened White River Turnpike. The business changed hands numerous times until acquired in 1848 by Luther Pease, whose family continued a hotel operation at this location on the north side of Main Street for the next 60 years. (Courtesy Hartford Historical Society.)

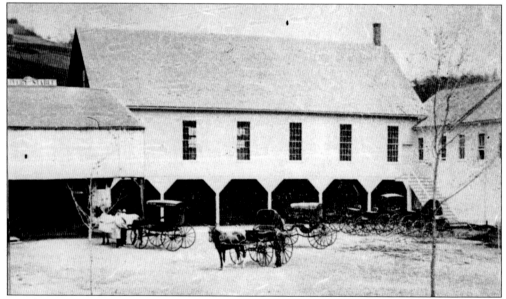

Hotels and taverns that served the busy stage lines running on turnpikes and highways in the first half of the 19th century not only provided overnight accommodations for travelers but also stable facilities for the teams of horses that pulled the passenger and freight vehicles. And for the stage lines, there was the need to change teams at periodic intervals. This early view illustrates the large stables attached to the rear of the Pease Hotel. (Courtesy Hartford Historical Society.)

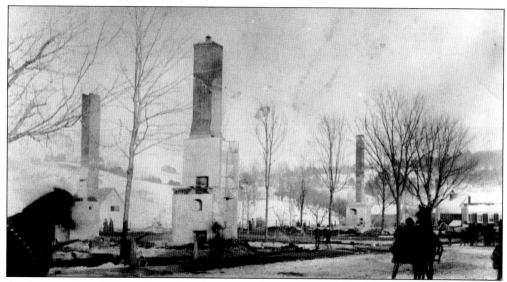

On January 24, 1889, the Pease Hotel was completely destroyed by fire, as shown in this view looking east from Main Street. Owner Charles Pease used his home on School Street until a new, more modern facility could be constructed on the site of the old destroyed building. (Courtesy Hartford Historical Society.)

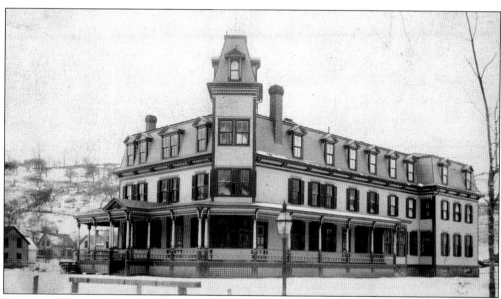

Pease quickly went about the business of constructing a new hotel in 1889 at a cost of $22,000. Considered to be one of the best facilities in the area, the Pease family sold it in 1908 to Addison Ely of New Jersey, who changed the name to the White River Tavern. Business declined to the point that in 1919, the building was razed for its salvage. (Courtesy Hartford Historical Society.)

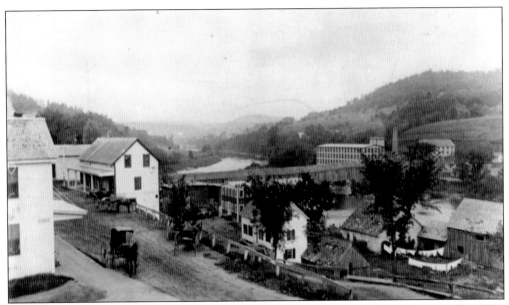

As early as 1792, the Vermont legislature passed an act granting Hartford a lottery to fund the construction of a bridge over the White River at Hartford Village, but it appears one was not built later than 1796. Subsequent replacement bridges were constructed at this location in 1814 and again in 1836, as shown in this 1880s view looking south down the White River valley. To the left is Main Street. (Courtesy Hartford Historical Society.)

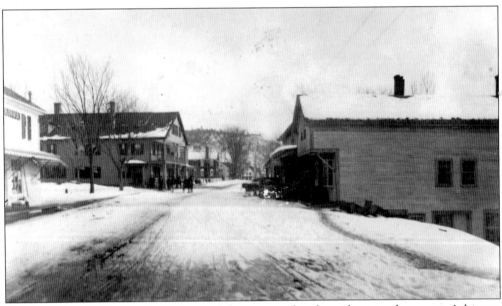

On the night of February 5, 1887, one of the worst railroad accidents in the country's history occurred several miles west of Hartford Village at the bridge crossing the White River. The following day, the building shown to the right of this view looking east along Main Street was quickly transformed into a morgue for the 31 persons who perished in the fiery tragedy. To the left is the Pease Hotel. For more on the accident, see page 92. (Courtesy Hartford Historical Society.)

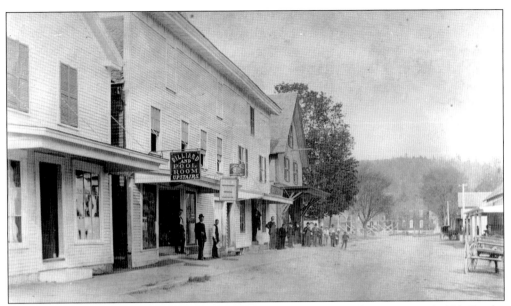

This view of Hartford Village looks east along Main Street in the summer of 1889. In the distance is the new Pease Hotel under construction (also see page 17). The large building in the middle foreground housing the second-floor billiard and pool room looks to be an older structure that has received a newer false front, making it appear more modern and substantial. (Courtesy Hartford Historical Society.)

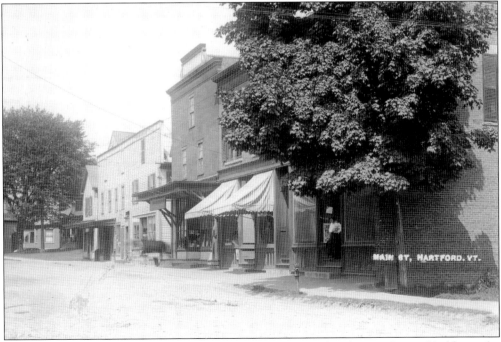

This early-20th-century view looks west along the north side of Main Street. Visible in the foreground is a newer brick commercial block. By this date, due to the increased manufacturing and woolen mill employment within the immediate area, the community and its Main Street became quite prosperous. (Courtesy Hartford Historical Society.)

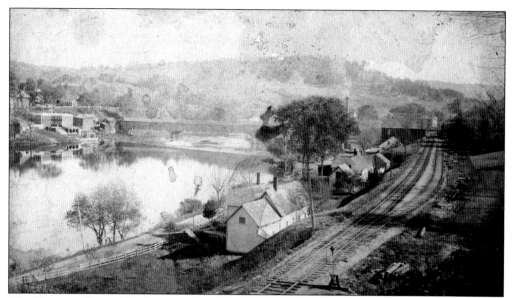

The Vermont Central Railway, as it was first chartered, established regularly scheduled service up the White River valley to Bethel beginning on Monday, June 26, 1848. From the start, the line was constructed passing by Hartford Village along the south bank of the river, where siding, depot, and freight buildings were built, a great benefit to the growth of the community, as seen in this 1880s view looking east. (Courtesy Vermont Historical Society.)

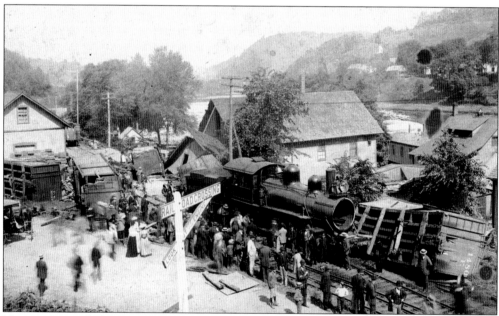

Historical records do not appear to tell the cause of this accident, which occurred about 1900, at the Hartford Village depot. However, it made a mess that blocked the highway crossing as well as the railroad tracks. It does look like perhaps the steam boiler exploded and blew the front of the locomotive off. Regardless, village residents seem to have enjoyed the entertainment. (Courtesy Hartford Historical Society.)

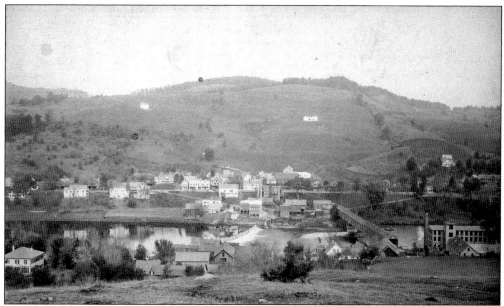

Looking from about the location of present-day U.S. Route 4, this is Hartford Village as it appeared in 1887. On the north bank of the White River is a carriage house and blacksmith shop belonging to Jonathan Bugbee and a three-story chair factory owned by Isaac Gates. In the lower right corner beside the covered bridge is the Hartford Woolen Company's mill facility. (Courtesy Hartford Historical Society.)

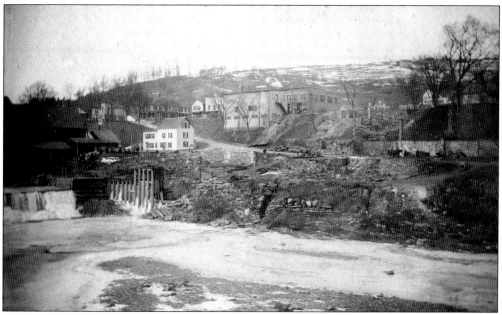

On Friday, December 15, 1904, a fire in the White River Chair Company in Hartford that was thought to be extinguished reignited and quickly spread to neighboring buildings, at times threatening the entire village. The loss, estimated at $42,000, included the chair factory, carriage and harness shops, a grain dealer's establishment, and a tenement house. More than 70 persons were employed in the chair factory alone. (Courtesy Hartford Historical Society.)

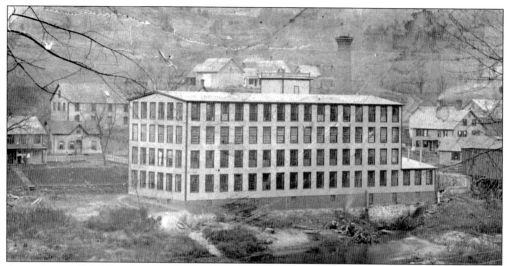

As early as 1823, Elias Lyman III established a cotton mill on the south bank of the White River beside the bridge crossing. Lengthy legal and business issues and the destruction of the building by fire in 1835 terminated this first effort. In 1853, the site was rebuilt, first as a mill for grinding plaster and then later adding equipment for manufacturing chair stock. This building was erected in 1887 on that site as a new woolen mill. (Courtesy Hartford Historical Society.)

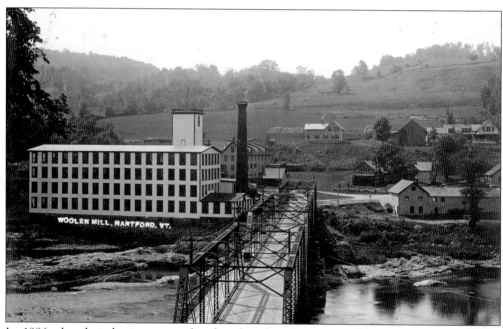

In 1886, the chair business was abandoned and a new group of local investors organized the Hartford Woolen Company. In addition to showing the river side of the mill, this early-20th-century view shows the modern steel highway bridge erected in 1892 to replace the aging and by then unsafe wooden covered bridge built in 1836. To date, five different bridges have spanned the river at this location. (Author's collection.)

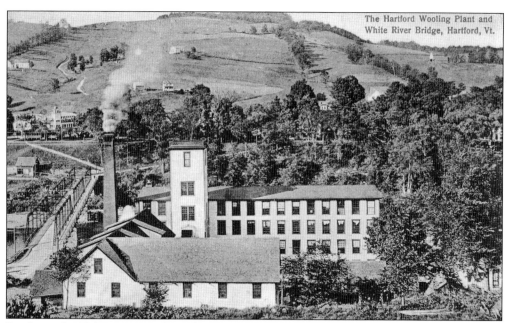

The Hartford Wooling Plant and White River Bridge, Hartford, Vt.

By the early 20th century, when this postcard view of the Hartford Woolen Company was published, the mill complex had become the biggest building and largest employer within the Hartford Village area. Located adjacent to good rail and highway access, the operation under the direction of the Cone family became a well-established and profitable business. This view looks north across the White River. (Author's collection.)

At the end of April 1957, after 70 years of continuous operation, the Hartford Woolen Company permanently closed its mill operation in Hartford Village. In 1972, after years of the building being used for storage, it was converted into a multibusiness facility known as the Trade Center; however, on the night of Friday, February 6, 1976, the building quickly and completely burned in a spectacular fire of undetermined origin. (Courtesy Hartford Historical Society.)

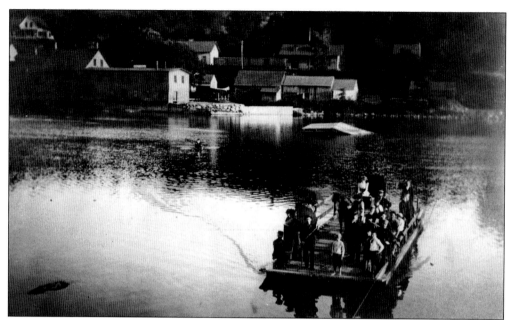

Prior to the construction of bridges across the rivers, ferries were often utilized during months when the streams were free of ice. And during times that bridges were either unavailable due to flood damage or replacement, temporary ferries reappeared. During the 1892 construction of the replacement steel bridge at Hartford Village, this temporary ferry navigated between the banks of the White River. The south bank is visible beyond. (Courtesy Hartford Historical Society.)

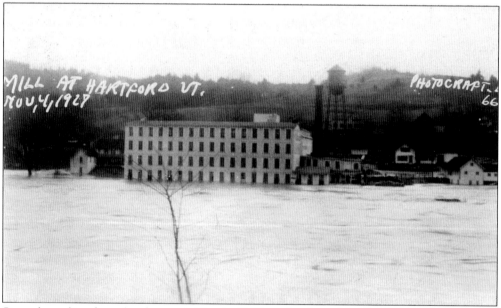

Since the earliest days of settlement in Hartford Village, flooding of the White River has remained a constant danger and problem. Although numerous and periodic floods have affected the area, by far the most destructive was the great November 1927 flood. Statewide, 75 persons lost their lives, and losses were in excess of $30 million. The White River valley was especially hard hit, as this view of the Hartford Woolen Company facility illustrates. (Author's collection.)

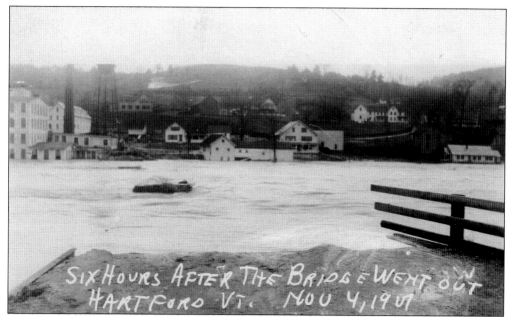

The White River started rising very suddenly on Thursday evening, November 3, 1927. On Friday, work was suspended at the Hartford Woolen Company and the workforce sent home. Later in the morning, as floodwaters on the White River continued to rise and debris piled up against the steel highway bridge, the 35-year-old structure was dramatically swept away. (Author's collection.)

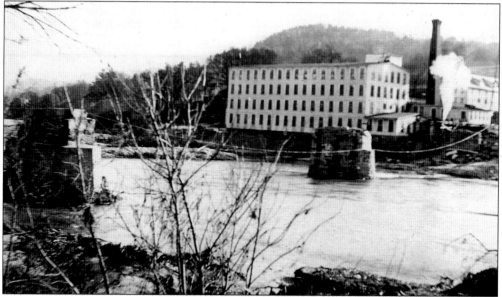

Almost as quickly as the floodwaters had risen within the White River basin at Hartford Village in November 1927, they quickly subsided, leaving behind grim scenes of destruction throughout the town of Hartford. At Hartford Village, temporary electric and telephone cables were soon placed across the river, supported by the destroyed bridge's remaining stone abutments. After considerable effort, the woolen mill was cleaned up and back in operation. (Courtesy Hartford Historical Society.)

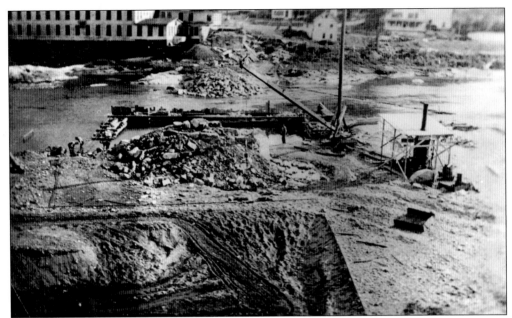

Work began on a replacement bridge in August 1928. At $96,592, the low bidder to the State of Vermont was J. A. Greenleaf and Sons of Auburn, Maine. One of the new concrete piers had to be carried 24 feet below the riverbed in order to reach ledge. This in turn required the construction of a large cofferdam outfitted with centrifuge pumps discharging streams of water from 16-inch-diameter pipes. (Courtesy Hartford Historical Society.)

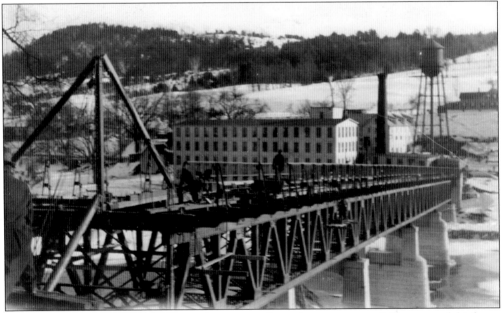

During the winter of 1928–1929, work continued on the new state-of-the-art steel highway bridge. Steel sections arrived by rail to the construction site. Not only was this bridge crossing important to the local Hartford community, but it was also important to the rapidly emerging state highway network. Forty years later, with the completion of the interstate highway system in the region, this crossing became less essential. (Courtesy Hartford Historical Society.)

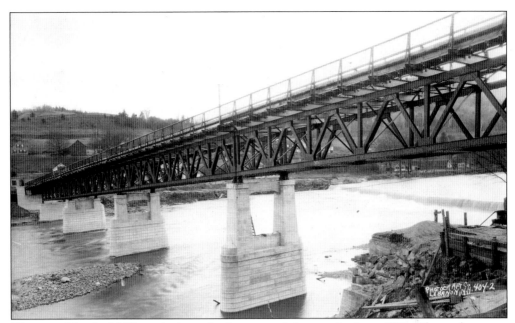

The new Hartford Village highway bridge opened for use in June 1929. The replacement structure was raised 80 feet above the river to prevent future flood destruction as well as to make for straighter approaches to the bridge for motor vehicles. The 550-foot bridge was the longest of more than 1,300 built after the November 1927 flood. In the foreground is the northerly approach and abutment to the prior bridge. (Courtesy Hartford Historical Society.)

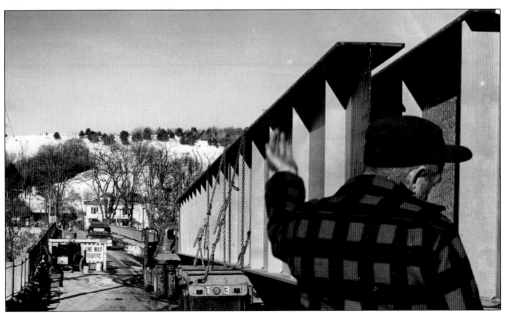

By 1966, a new bridge was being constructed across the White River at Hartford, this time to carry Interstate 91 northward up the Connecticut River valley. Large sections of steel girders arrived by railroad to the south side of the White River and were carefully and slowly transported across the Hartford Village bridge and then east down Main Street/Route 14 to the construction site and awaiting cranes. (Courtesy Hartford Historical Society.)

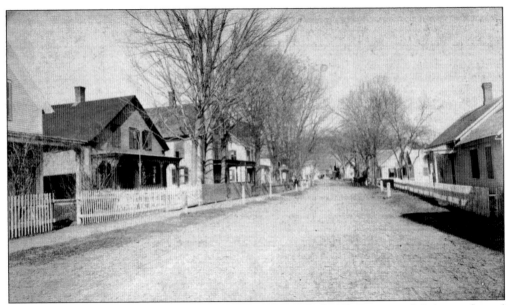

As manufacturing grew during the 19th century at Hartford Village, so too did the residential areas of the community, providing modest but contemporary housing for mill workers. Almost all the structures were wood frame, one and a half to two stories, and on small, individual village lots. (Courtesy Hartford Historical Society.)

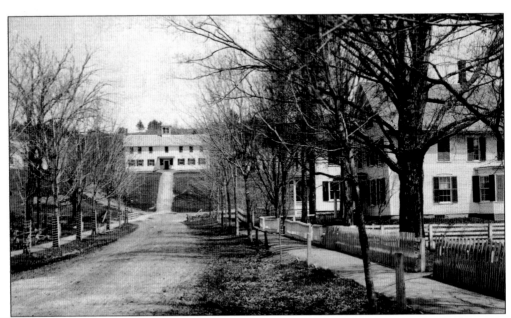

Although early records are vague, it appears that there was an elementary school of sorts in Hartford Village about 1800. In 1839, Hartford Academy was established as a private institution; however, not being successful, the building, illustrated here, was purchased by the town in 1848 for $337.50 and utilized until its replacement in 1907. During that time, it was slightly moved, remodeled, and enlarged. (Courtesy Hartford Historical Society.)

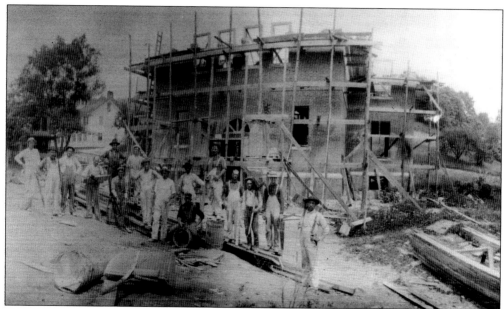

By 1907, it became necessary to replace the aging wood school building with a more modern, safer, and spacious facility. The old structure was temporarily moved over to the playground for continued use while a new masonry building was erected that year. To the left (west) of this construction view of the new facility is the old building. (Courtesy Hartford Historical Society.)

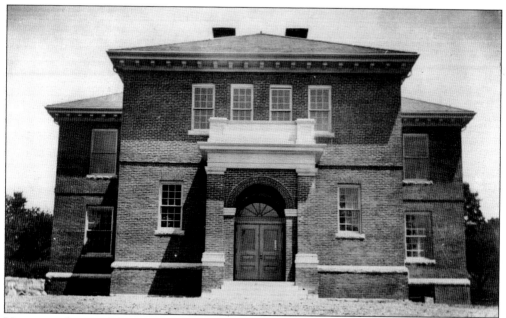

Upon completion of the new state-of-the-art facility handsomely designed in the then-favored Colonial Revival style, the old school building was stripped of its desks, blackboards, and other useful items and then sold at a public auction for $125. The old wood-frame building is now long gone; however, the new 1907 building is still standing looking down School Street. (Courtesy Hartford Historical Society.)

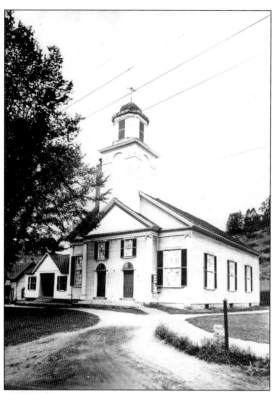

First known as the Congregational Society of White River Village when organized in November 1827, by the following year, a new meetinghouse was designed and erected. A parsonage was added in 1848 and a vestry in 1860. In 1903, Louis Sheldon Newton, a successful architect living in Hartford Village, remodeled the interior to enrich it and have it better harmonize with the exterior. (Courtesy Hartford Historical Society.)

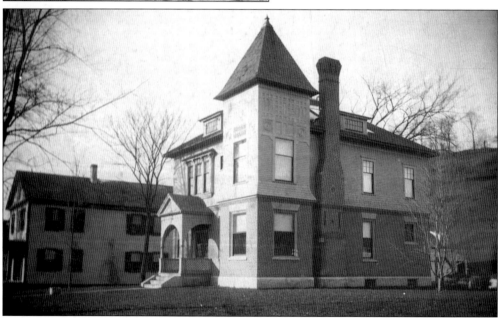

A group of Hartford Village citizens and local businessmen formed a corporation under Vermont law on July 1, 1892, for the purpose of establishing a community library to be constructed within the village area. The design and construction proposal of Lyman Whipple of Lebanon, New Hampshire, was selected in September of that year. The spacious, new facility was dedicated on September 16, 1893. (Courtesy Hartford Historical Society.)

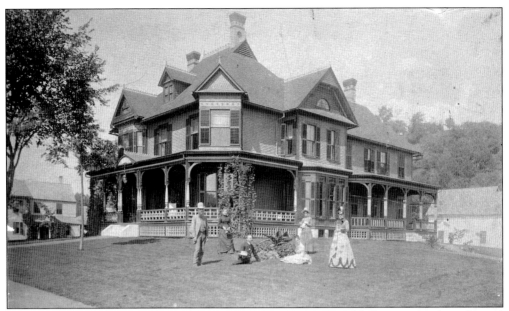

The decades following the American Civil War were a time of wealth for many in the industrial Northeast, especially in areas with abundant waterpower for manufacturing and transportation facilities to move goods, raw materials, and finished product. Representative of that era is this substantial Queen Anne–style house erected in the later 19th century, overlooking the White River at the north end of the village. (Courtesy Hartford Historical Society.)

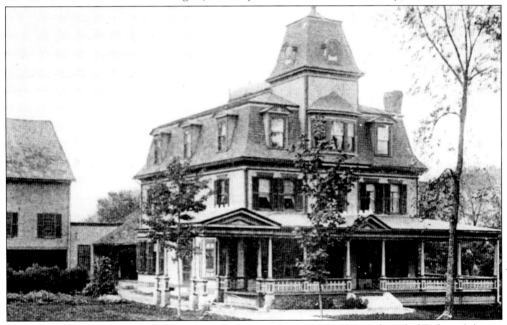

Originally constructed in 1795 as a simple two-story home with a hipped roof of Colonial design by Josiah Tilden, the house was later owned by Edwin C. Watson, a partner in a thriving farm implement business (see page 14). It was he who, in the later 19th century, extensively remodeled the structure in the very popular "French" or Second Empire style, a common practice during that period of national prosperity. (Courtesy Hartford Historical Society.)

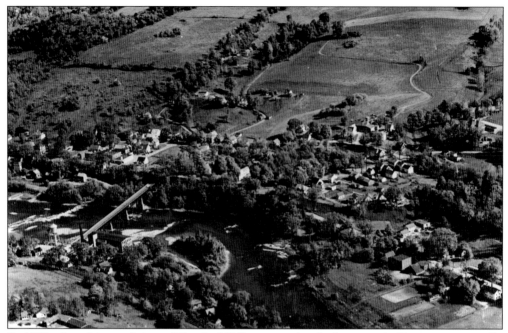

By 1950, when this aerial view of Hartford Village was taken looking north, Vermont was rapidly changing, but the area still had a balanced mix of manufacturing, agriculture, and small, local village community retail. Not too many years later, the Hartford Woolen Company closed. (Courtesy Hartford Historical Society.)

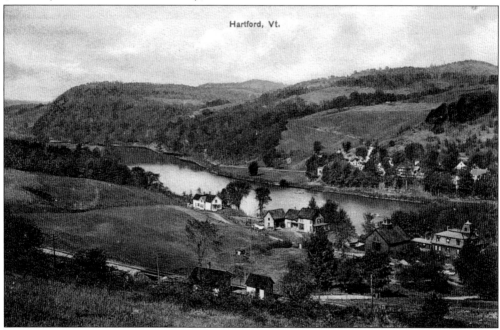

This view taken about 1910 of the westerly end of Hartford Village looking north at the far lower right shows Edwin Z. Watson's Victorian home. In the center foreground is the small depot and freight house of the Woodstock Railway, the present location of U.S. Route 4. (Author's collection.)

Two

QUECHEE VILLAGE, DEWEY'S MILLS, AND THE WOODSTOCK RAILWAY

Quechee Village, somewhat centrally located within the town of Hartford, was the location of the town's first saw- and gristmills at a location of significant falls on the Ottauquechee River. The name Quechee is said to have been derived in an abstract way from Native American dialect describing this area. The above view of the village was taken in 1900, looking north toward the village in the Ottauquechee valley. (Courtesy Vermont Historical Society.)

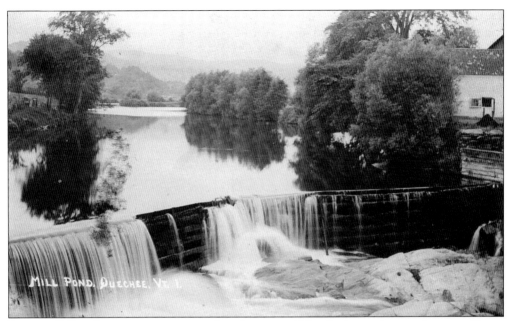

Prior to 1769 and not too many years after the town of Hartford was chartered, a sawmill was erected at the falls in present-day Quechee Village. By about 1774, a gristmill was also being powered by the waters of the "Otta Quechee," "Water Queechy," or "Queechy" river, as early settlers referred to the Ottauquechee River. This postcard view of the milldam and pond at Quechee Village was taken about 1910. (Courtesy Hartford Historical Society.)

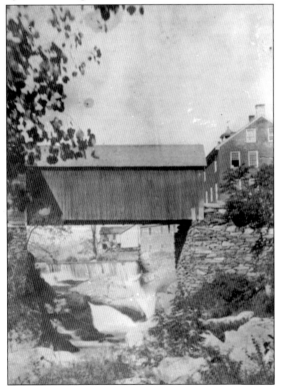

At about the same time that the first sawmill was established on the Ottauquechee River at Quechee, so too was a simple, open, wooden bridge constructed in 1769. In 1803, this wooden covered bridge replaced the earlier deteriorated structure and remained in place until replaced in 1885. This early photograph, looking upriver toward the milldam, was probably taken in the 1860s. (Courtesy Hartford Historical Society.)

Between 1807 and 1813, Elisha Marsh and Eleazer Harwood began what would come to be a very substantial textile mill complex when they constructed a brick building at the falls and installed carding machines. Although quickly and often changing hands, development of the site continued until a freshet in October 1869 undermined the north wing of the factory, collapsing it into the river. (Courtesy Hartford Historical Society.)

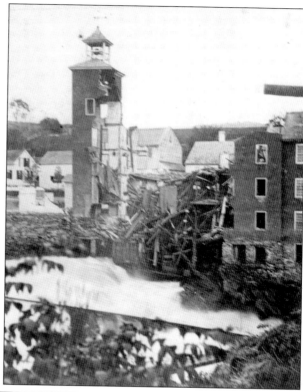

This is another view of the collapsed mill building after the October 1869 freshet. This view, taken looking from Main Street, shows a portion of the covered bridge in the background. Not only was a lot of valuable machinery either lost or seriously damaged, but also a large quantity of wool was lost. Rebuilding of the facility soon commenced. (Courtesy Hartford Historical Society.)

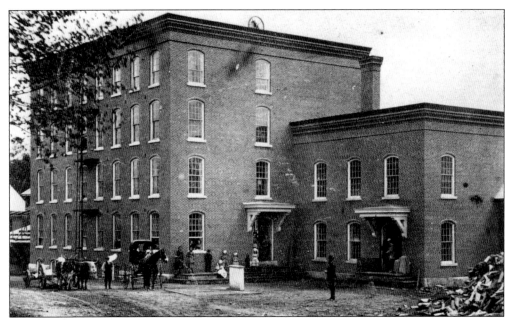

Following the October 1869 collapse of the original section of the mill complex, J. C. Parker and Company immediately rebuilt a larger and more modern facility than had previously existed. By the 1870s, this complex was one of 45 woolen mills in Vermont and was generating 35 percent of the estimated $3.5 million wool revenue of the entire state. (Courtesy Hartford Historical Society.)

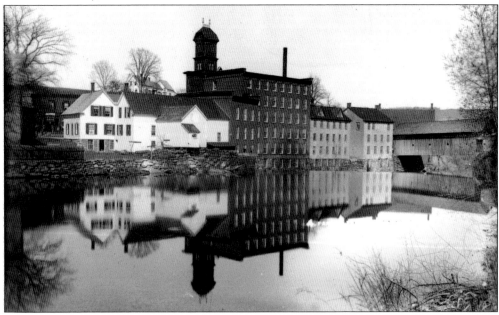

This early-20th-century view shows the entire J. C. Parker and Company mill complex from the south side of the Ottauquechee River. In 1906, Robert and Almon Harris purchased the business and property, changing the name to Harris, Emery Company. By this time, both water and actual horsepower operated 26 looms and 28 card sets while employing more than 75 people. (Courtesy Dartmouth College Special Collections.)

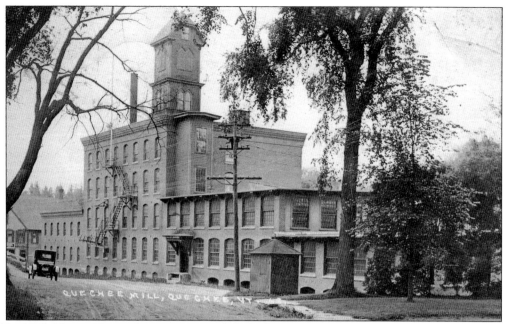

In 1915, Harris, Emery Company expanded the building and, as a result, nearly doubled the mill's output capacity. The expansion, as seen in this 1920s view looking at the facility from Main Street, added new drying room and sales areas and expanded the weaving room floor area. (Author's collection.)

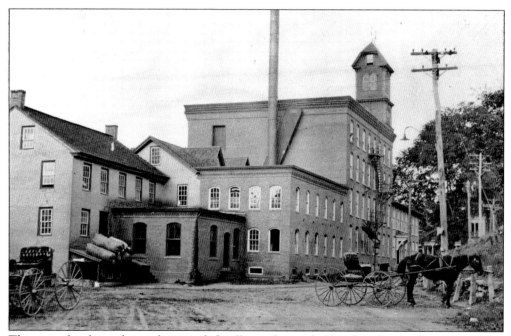

This view also shows the newly expanded mill complex, probably taken shortly after construction of additions in 1915, looking up Main Street from about opposite the intersection and covered bridge. Employing 100 persons by 1924, the mill was producing 5,000 yards of fine, white flannel per day. (Courtesy Hartford Historical Society.)

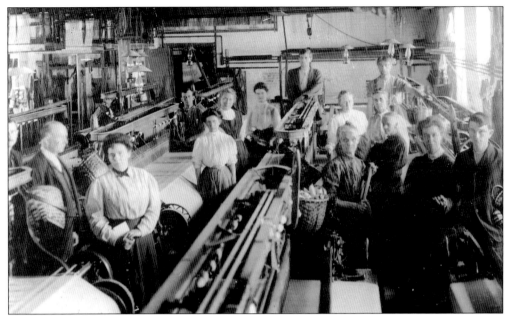

Typically in woolen mills at the dawn of the 20th century, women were the weavers, tending the looms as seen here at Quechee about 1900. As weavers, they were constantly walking and standing for hours on end as they tended their machines, while bending and stooping to take bobbins from baskets or mending and tying knots in broken wraps. (Courtesy Hartford Historical Society.)

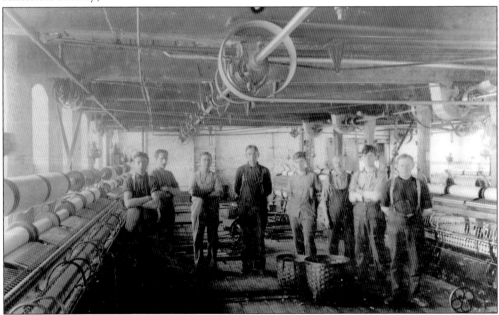

For the men working in the Quechee mill, the dress was typically blue denim bib overalls with short-sleeved shirts because of the constant lifting of materials and the heat inside the building. During the summer months, some accounts state it was literally steaming hot. Nonetheless, the pay was better than farmwork and no more physically demanding. (Courtesy Hartford Historical Society.)

Shortly after Joseph C. Parker arrived in Quechee as one of the new owners of the woolen mill on Main Street in 1857, he constructed this fashionable and ornate "French" Second Empire–style residence for himself adjacent to his mills. In the mid-1960s, fire extensively damaged the building; however, not too many years later, Quechee Lakes Corporation carefully restored the property to its original splendor. (Courtesy Hartford Historical Society.)

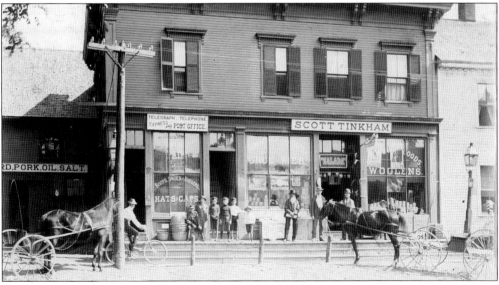

Quechee Village, as it was first called, was the second location within the town of Hartford to receive a post office on May 8, 1827. The postal service changed the name to Queechy in 1855 and finally settled on just Quechee in 1868. For many years, the post office was in Scott Tinkham's store, located across Main Street from the mill, as seen in this 1900 view. (Courtesy Hartford Historical Society.)

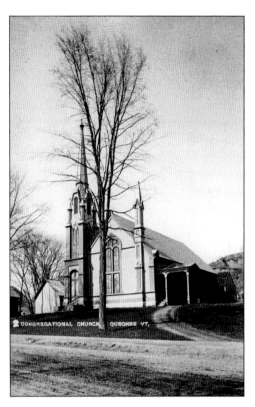

As early as 1831, the First Congregational Church was organized in Quechee Village. Several years later, it constructed its first building. In 1873, this second facility was completed and dedicated in May. This mildly ornate Carpenter Gothic–style structure still stands on Main Street in the village. (Author's collection.)

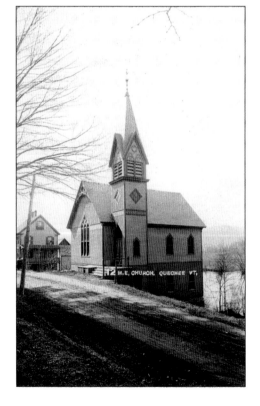

The Methodist Episcopal Church was first organized in Quechee Village in 1882; however, it was not until 1887 that, on a somewhat challenging lot on River Street, it erected this Carpenter Gothic–style facility designed by architect B. D. Pierce of Philadelphia. This finely appointed building, complete with a bell, was used by the society until 1912 and then sold to the Congregationalists. (Author's collection.)

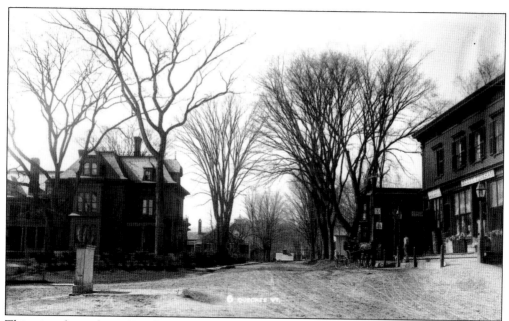

This view from about 1910 looks westerly up Main Street from opposite the west end of the Harris, Emery Company mill complex. To the left is the substantial home of Joseph C. Parker, erected in 1857. To the right is Scott Tinkham's commercial building where he kept the village's general store and post office as well as the express agent's office. (Courtesy Dartmouth College Special Collections.)

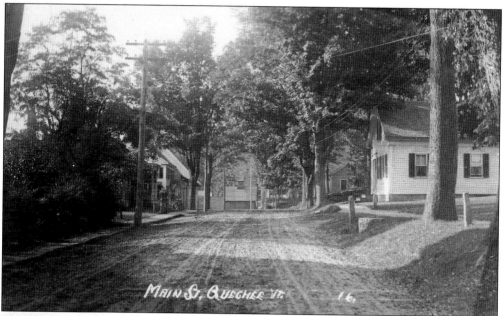

West of the village center, Main Street in Quechee Village was entirely a residential area of mill worker housing that gradually transitioned into farms beyond the village area. Prior to the relocation of U.S. Route 4 to the old right-of-way of the Woodstock Railway in 1933, this was one of several main roads west out of the Connecticut River valley across Vermont when this postcard image was created about 1910. (Courtesy Hartford Historical Society.)

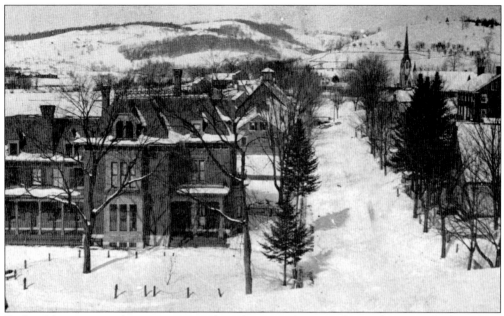

Both of the views on this page were made perhaps on the same day in the 1880s, looking from the roof of the J. C. Parker and Company Woolen Mill. Here, facing northwest up Main Street in the left foreground, is Joseph C. Parker's home, located adjacent to his mill complex. In the midground on the right is the Congregational church, erected in 1873. (Courtesy Hartford Historical Society.)

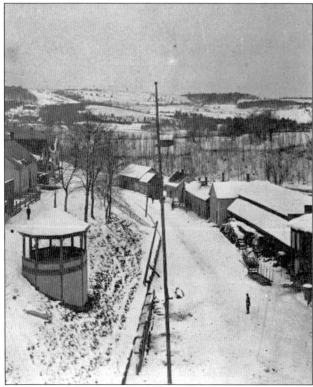

Facing southeast, this view looks down Main Street past the intersection of Bridge Street. To the left is the community bandstand. During the summer of 1891, the bandstand was renovated to become the village library under the direction of the Quechee Library Association. That year, the library had 1,679 volumes and membership was at 151 persons. (Courtesy Hartford Historical Society.)

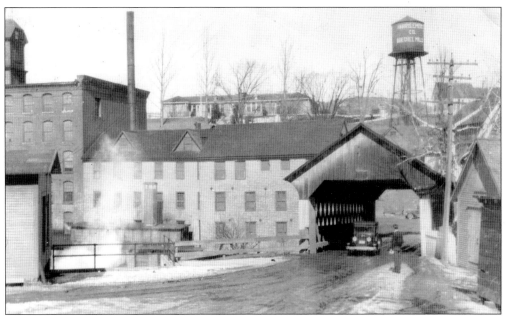

The horrific November 1927 flood badly damaged the Harris, Emery Company mill operations, and it took five weeks to recover. Even with the onset of the Great Depression in the early 1930s, when this image was made, the mill kept in operation. By 1933, the wood-covered bridge erected in 1885 was nearing 50 years old and was replaced by a new concrete span that year. (Courtesy Hartford Historical Society.)

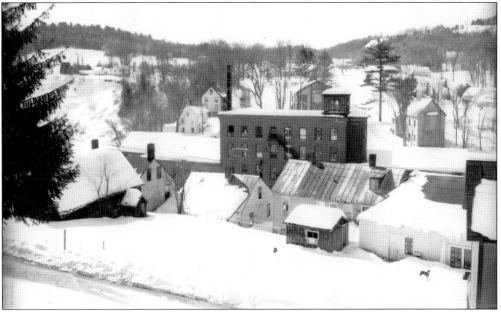

Harris, Emery Company permanently closed its woolen mill facility in Quechee Village on February 1, 1957, and the equipment was relocated to a site in Penacook, New Hampshire. In the mid-1950s, the property was sold to several local mill owners; however, they never used the complex. Instead, the taller, easterly section of the building was demolished with dynamite in March 1964. (Courtesy Hartford Historical Society.)

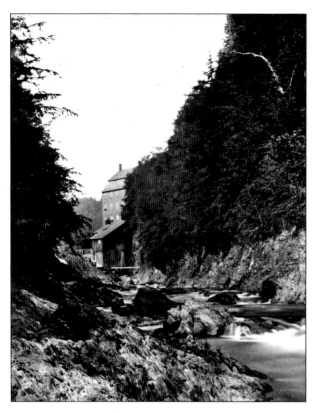

Albert Galatin Dewey, born in Hartford of very modest means in 1805, founded the first reworked or shoddy woolen mill in the country when he constructed it at the head of Quechee Gulf in 1836. The first 20 years were very difficult for the enterprising and persistent Dewey; however, by the time this photograph was taken about 1870, looking up the Ottauquechee River toward the mill, the business had become quite successful. (Courtesy Woodstock Historical Society.)

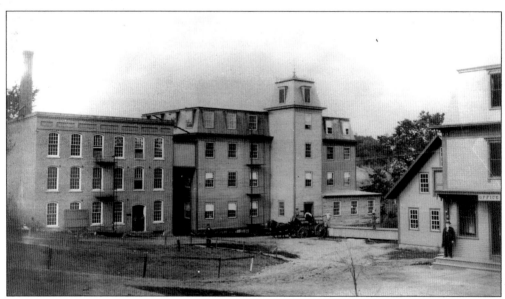

During the decades following the American Civil War, the business continued to grow and prosper. Dewey's two sons, John J. and William S., joined the business in 1874 and 1876, respectively, and mill and related buildings were expanded and others added at the Quechee Gulf site. Dewey, shown standing on the front porch of the office building in this early-1880s photograph, died in 1886 at age 81. (Courtesy Woodstock Historical Society.)

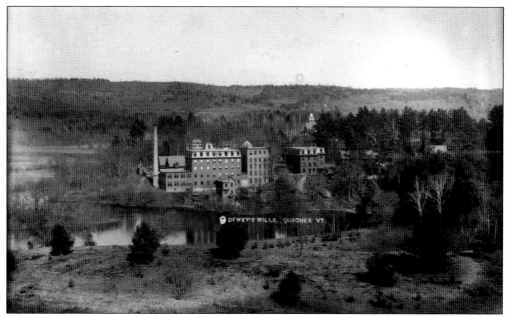

The Dewey mill complex was converted to electricity in 1889 after a new 150-horsepower Hercules waterwheel was installed in the powerhouse under 20 feet of head provided by an improved dam across the Ottauquechee River. When this photograph was made of the complex about 1910, the mill employed more than 100 persons who produced 2,500 yards of cloth daily on six sets of machinery. (Courtesy Dartmouth College Special Collections.)

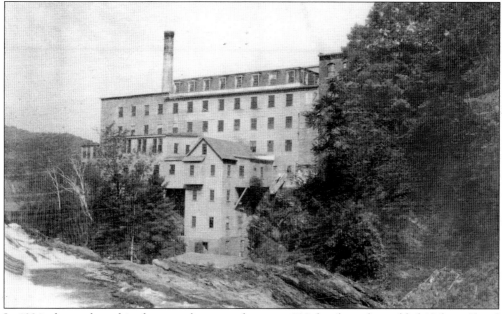

In 1924, about when this photograph was made, a new 220-foot-long dam added 10 feet of head and flooded 75 additional acres. This increased water storage capacity and power and added electrical generation and manufacturing output at the site. The A. G. Dewey Company's insurance inspectors commented on the mill's cleanliness and excellent working conditions for the employees as well as offering group insurance. (Courtesy Hartford Historical Society.)

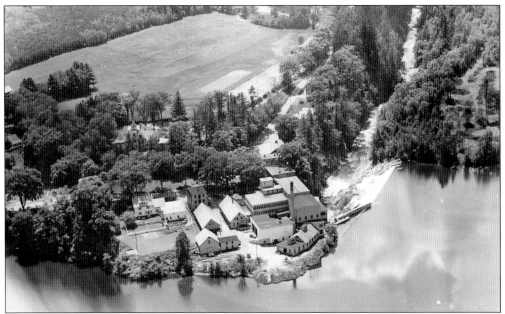

Both of the aerial views of Dewey's Mills on this page are believed to have been made the same day at the time of the company's 100th anniversary in 1936. By that time, the company had 190 employees making 30,000 yards of cloth per week and was being run under the capable guidance of Albert Galatin Dewey's grandson James F. Dewey and great-grandson William T. Dewey. (Courtesy Hartford Historical Society.)

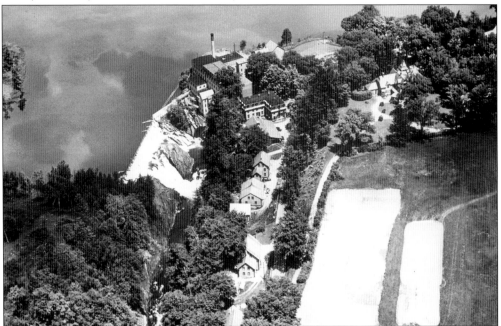

By 1936, Dewey's Mills had its own post office within the mill complex. The company owned 1,400 acres of land and 63 buildings. Employees had a ball field and gun club as well as access to boardinghouses and rental homes. To the right is the Dewey homestead, Birchwood, built in 1895. In the lower left is Quechee Gorge. (Courtesy Mark Pippen.)

During the afternoon of October 1, 1957, A. G. Dewey Company president William T. Dewey announced that because of construction of a proposed new flood control dam on the Ottauquechee River at North Hartland, the mill complex was going to close and operations would be dispersed to other locations. In 1962, after the federal government had condemned the mill buildings and claimed the land, the mill complex was completely razed. (Courtesy Hartford Historical Society.)

Another casualty of the North Hartland Flood Control Dam project, constructed in the late 1950s, was the home erected by Col. Joseph Marsh in 1792, located near the Ottauquechee River and Dewey's Mills. In 1960, after this photograph was made of the historic home, the building was moved to higher ground and is today a part of the Quechee Inn at Marshland Farm. (Courtesy Hartford Historical Society.)

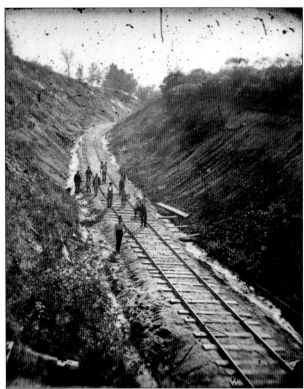

Since the earliest days of railroads in Vermont, the idea of constructing a route west across the state from White River Junction through Woodstock had been on men's minds. In 1863, the Woodstock Railroad Company was created, and by April 1868, work began with the deep and long cut that had to be made at Shallies Hill. By May, 500 men, paid $1.75 per day, were digging by hand from both sides of the hill in the location of today's U.S. Route 4. (Courtesy Vermont Historical Society.)

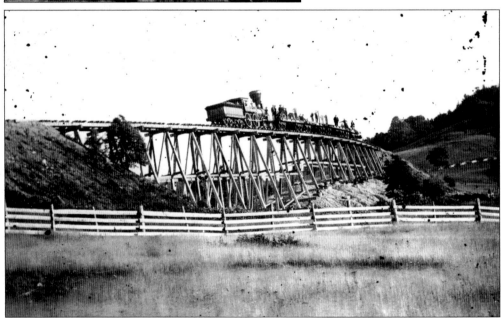

Often, in an attempt to speed early railroad construction, trestles were first erected crossing low terrain, and then once operation of the road began, fill was added, building up around the temporary wood construction. Here the veteran work engine *Winooski* is aiding a work crew doing trestle filling about where present-day U.S. Route 4 and Interstate 89 cross. (Courtesy Woodstock Historical Society.)

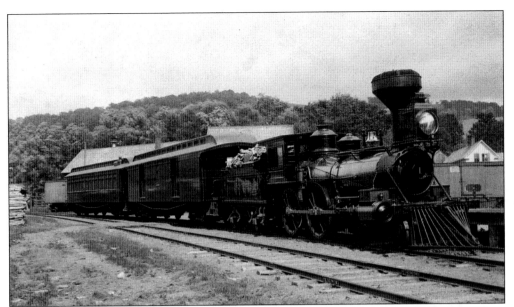

The first locomotive to be purchased to run on the 13.88-mile-long railroad between White River Junction and Woodstock when complete in 1875 was the A. G. *Dewey*, named for one of the railway's principle investors. However, that locomotive proved heavier than was needed and in 1882 was traded to another railroad for a lighter unit, shown here, also a wood-burning steam unit that too was named the A. G. *Dewey*. (Courtesy Woodstock Historical Society.)

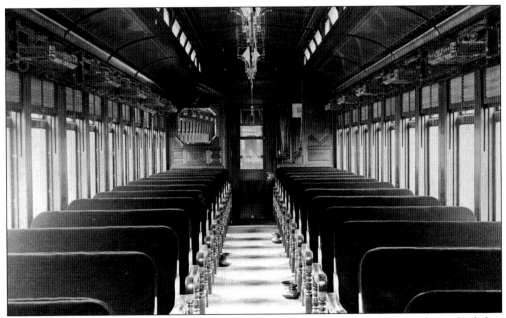

The Woodstock Railway, throughout its 58 years of successful operation, always had fine equipment that was well maintained. This unique early photograph is an interior view of the railroad's first purchase, a combination baggage and passenger car named *Woodstock*. Note the kerosene lighting chandeliers and brass parcel racks above the windows. (Courtesy Woodstock Historical Society.)

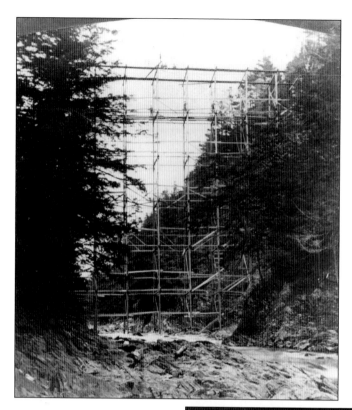

Prior to construction of the railroad, engineers examined four possible routes for getting the tracks to Woodstock. It was boldly decided to bridge Quechee Gulf—the shortest route. In July 1875, R. E. Peabody, a bridge builder from Groton, erected temporary scaffolding, 135 feet high, on which the new bridge would be erected. Two stone end abutments were constructed earlier. (Courtesy Woodstock Historical Society.)

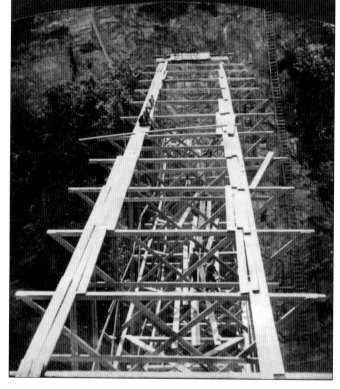

By late July 1875, rails were in place from White River Junction to the eastern rim of the gorge, allowing work trains to transport prefabricated, numbered wood and iron parts of the bridge. This view shows the top of the scaffolding leveled and ready to receive bridge components and workers connecting these pieces. (Courtesy Woodstock Historical Society.)

On August 12, 1875, in hushed fascination, hundreds of observers watched as the work locomotive *Winooski*, already a historic locomotive (see page 59), crept cautiously across the new bridge, a Howe truss design of wooden horizontal and diagonal members and iron vertical tension rods. The bridge gave no more than a quarter inch of deflection under the weight of the 23-ton steam locomotive and tender. (Courtesy Woodstock Historical Society.)

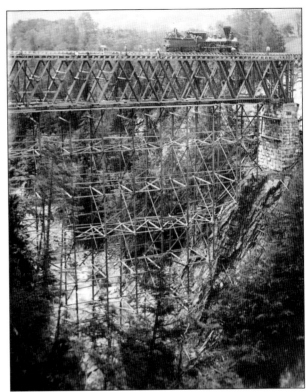

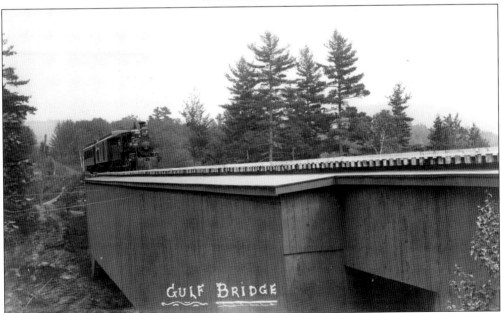

Soon after the historic test of the Gulf Bridge, vertical boarding was installed to protect the structure from weather-related damage, and the temporary scaffolding was removed from the gorge. The 163-foot-high bridge spanned 280 feet and cost in excess of $20,000. By mid-September 1875, rails had finally reached downtown Woodstock village. (Courtesy Woodstock Historical Society.)

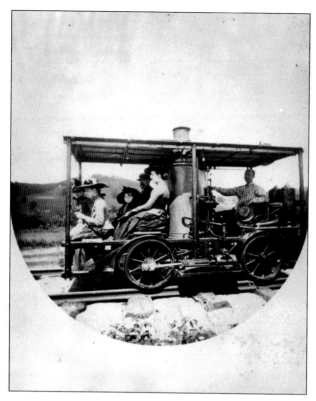

The Dewey family was one of the principle investors in the Woodstock Railroad Company, and Albert Galatin Dewey served as an early president of the line. In addition to providing service to the Dewey's Woolen Mills, the family had this steam-powered car made in 1878, named the *Gerty Buck*, for its personal use between Woodstock and White River Junction. (Courtesy Woodstock Historical Society.)

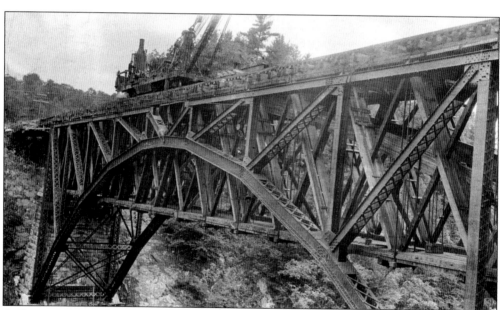

As locomotives and trains became heavier, it was necessary to reinforce the original Gulf Bridge with wooden arches. They were added in 1906, but this proved not enough. In 1911, the American Bridge Company constructed a new steel structure around the old 1875 bridge, all the while keeping the railroad open to daily traffic. Seen here is the last piece of steel ready to be set and riveted into place. (Courtesy Woodstock Historical Society.)

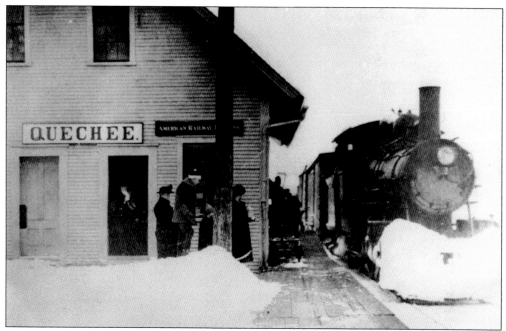

Faithfully, twice daily, the Woodstock Railway made round-trips between White River Junction and Woodstock Village, with scheduled stops along the way at Dewey's Mills, Quechee, and Taftsville. Hartford Village was a flag station (see page 32). In this scene is the eastbound locomotive No. 3, the *J. G. Porter*, with a mixed daily train at the Quechee station about 1920. (Courtesy Hartford Historical Society.)

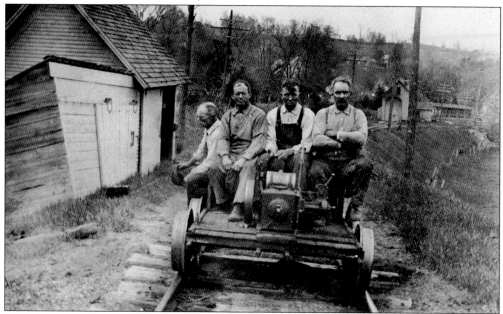

Every railroad requires routine maintenance, and the Woodstock Railway was no exception. Here, about 1920, is a section crew leaving Woodstock heading east to inspect track, check for washouts, and tend to any maintenance and repairs. Note the handcar, now powered by a single-cylinder gasoline engine. (Courtesy Woodstock Historical Society.)

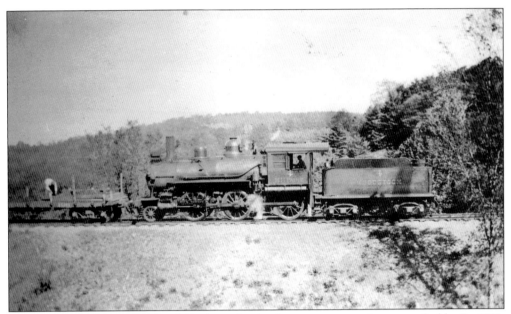

By the late 1920s, the Woodstock Railway, for the first time, was no longer profitable. By 1933, it ceased operation. The last scheduled run was made on Saturday, April 15, 1933, with 14 of the 350 passengers having been on the first scheduled run 58 years earlier. Later that summer, locomotive No. 4, the *H. H. Paine*, was used to pull a work train that took up the rails to be sold as scrap steel. (Courtesy Hartford Historical Society.)

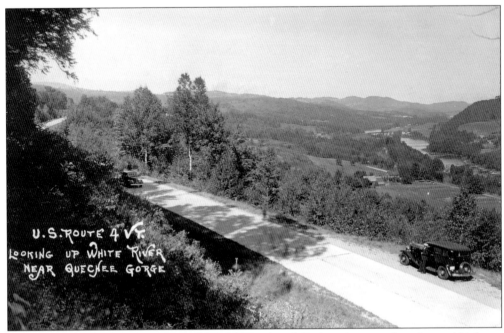

During 1933 and 1934, the roadbed of the old Woodstock Railway became the relocated highway U.S. Route 4. This postcard view, showing the White River valley in the background, was made at about the same location as the photograph above. In the far distance is the infamous Hartford railroad bridge (see page 92). (Author's collection.)

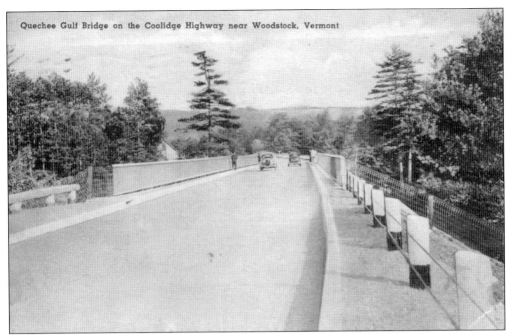

Beginning in the summer of 1933, the steel railroad bridge across Quechee Gorge, as it came to be called in the 20th century, was converted into a modern highway bridge for the relocated U.S. Route 4. The structure still carries traffic across the gorge, although much modified from its original 1911 state, and provides a good vantage point to view the great scenic chasm. (Author's collection.)

The rapidly increasing availability and popularity of the automobile as part of American life by the 1920s prompted the growth of numerous camps and tearooms, catering to the motoring traveler. With the relocation of U.S. Route 4 to the right-of-way of the old Woodstock Railway in 1933, similar new establishments popped up along the highway, especially in Quechee near the scenic gorge. (Courtesy Hartford Historical Society.)

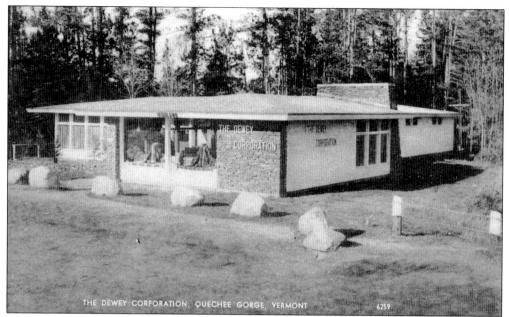

The Dewey Corporation, formerly A. G. Dewey Company, erected this mill ends fabric store and restaurant at the east edge of Quechee Gorge in 1947. Designed by Hanover, New Hampshire, architects E. H. and M. K. Hunter, the award-winning building was placed adjacent to the gorge and highway bridge that had by then become a major tourist attraction. (Author's collection.)

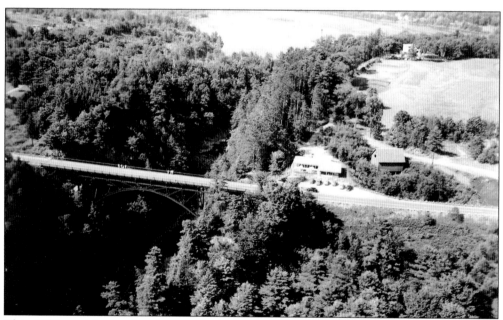

This 1950s aerial view looking north shows the 13,000-year-old gorge through which the Ottauquechee River runs. Also visible are the 1911 converted railroad bridge, the Dewey Corporation's new store, and in the far upper right, the Dewey family's 1895 home, Birchwood, which was extensively remodeled in 1947 and 1948, removing its early-Victorian character. (Courtesy Hartford Historical Society.)

Three

WHITE RIVER JUNCTION AND RAILROADS

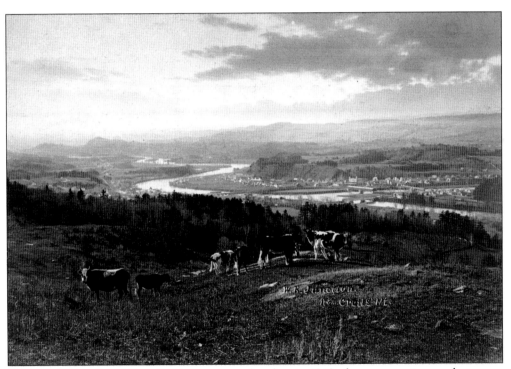

Prior to three railroad lines linking up to each other in 1848, the community now known as White River Junction was a nonvillage area of three family farms laid out on the broad flood plains at the convergence of two major rivers. This panoramic view looking from West Lebanon, New Hampshire, about 1880 shows the rapidly growing railroad hub that had become one of the most important in northern New England. (Courtesy Dartmouth College Special Collections.)

In November 1835, a state charter was obtained to construct a railroad across Vermont, connecting the Connecticut River with Lake Champlain. However, not until December 15, 1845, was construction actually started in Windsor. By early 1847, the Vermont Central Railroad, as it was first named, reached the farm of Col. Samuel Nutt, the area that would soon become part of a new village area and rail hub. This January 1849 photograph shows those historic railroad tracks. (Courtesy Hartford Historical Society.)

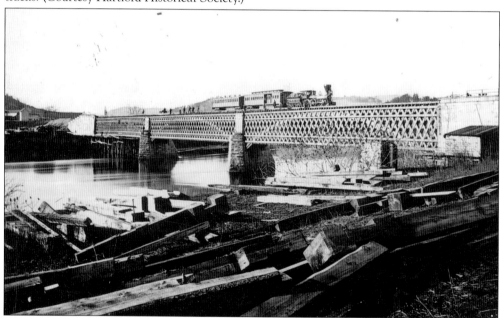

The Northern Rail Road of New Hampshire, chartered in 1837, was well financed and engineered from the start. Tracks from Concord, New Hampshire, reached the center of Lebanon in November 1847, and by June 1848, after construction of a 600-foot three-span bridge, the rails connected to the Vermont Central Railroad, creating White River Junction. This image shows construction of a replacement wooden bridge at that site in 1871. (Author's collection.)

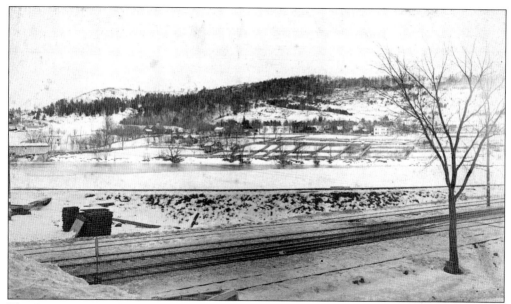

The Connecticut and Passumpsic Rivers Railroad was chartered by the state in November 1845 to build from the mouth of the White River north to the Canadian border. By 1846, construction had started in White River Junction. After completion of an expensive bridge over the White River, the first train ran as far north as Bradford in October 1848. This very early photograph was taken looking toward West Lebanon, New Hampshire, across those tracks. (Courtesy Vermont Historical Society.)

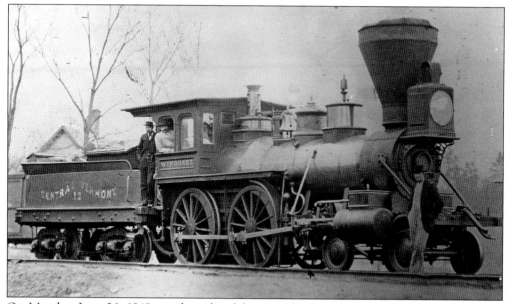

On Monday, June 26, 1848, amid much celebration, the first Vermont Central Railroad train left White River Junction to Bethel, a distance of 27 miles. It was the first train to run in all of Vermont. Within a year, the rails were completed across the state. The 23-ton wood-burning steam locomotive *Winooski*, seen here, pulled the historic train. Twenty-seven years later, the *Winooski* helped build the Woodstock Railway and also made the first run on that line. (Courtesy Hartford Historical Society.)

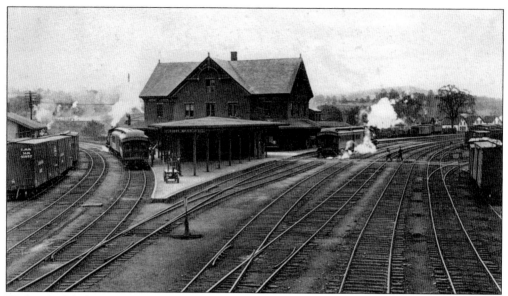

With scheduled train service beginning in 1848, White River Junction became a place with a name and a passenger depot. In 1861, a great fire destroyed many railroad-related buildings, including the depot. The brick building seen here, known as Union Station, was constructed soon after that devastating fire. This photograph looks south around 1895. (Courtesy Hartford Historical Society.)

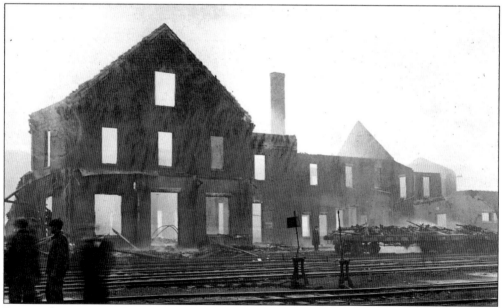

During the summer of 1911, Union Station received about $15,000 in needed renovations; however, at 4:00 a.m. on Tuesday, November 28, 1911, fire was discovered in a wall of the building, and by 6:00 a.m., the entire building was engulfed, The facility was a total loss. The telegraph office was hastily set up in a railway car, and a freight building quickly became the passenger depot. (Courtesy Hartford Historical Society.)

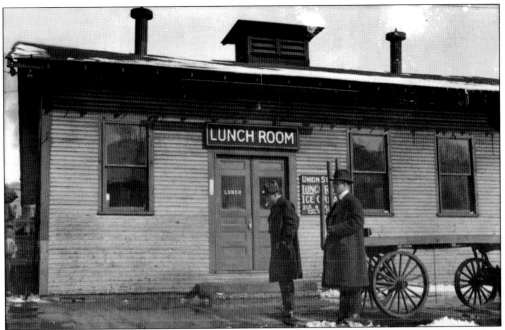

With the fiery destruction of Union Station and its large and elegant restaurant, the traveling public temporarily lost dining services. Until the completion of the new station in 1938, this lunchroom, hastily fashioned from an old freight building, provided travelers changing trains with a quick bite to eat. (Courtesy Hartford Historical Society.)

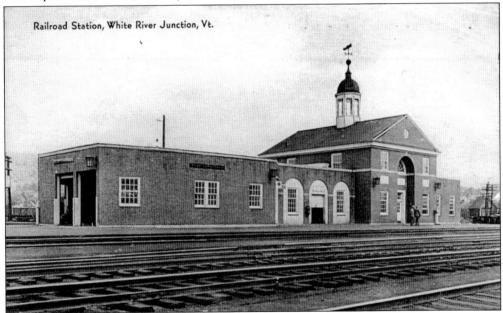

For 26 years, White River Junction had only temporary depot facilities for the traveling public. Finally, on December 8, 1937, this new building, constructed on the site of the former Union Station, was dedicated. Designed by Dartmouth College architect Jens Fredrick Larson, the building was a joint effort by the Central Vermont Railway and Boston and Maine Railroad. (Author's collection.)

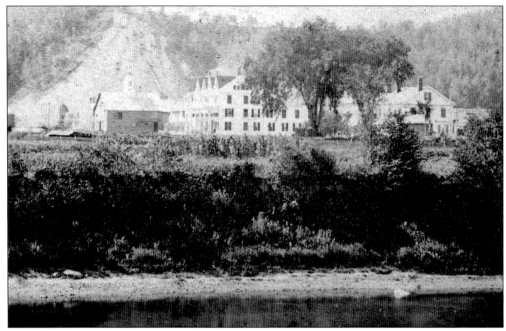

To construct the railroad lines and have them located above the flood plain of the two rivers, it was necessary to first build up the roadbed. The gravel embankment behind the new village area provided this much-needed material, as seen in this very early view looking from the White River about 1860. (Courtesy Hartford Historical Society.)

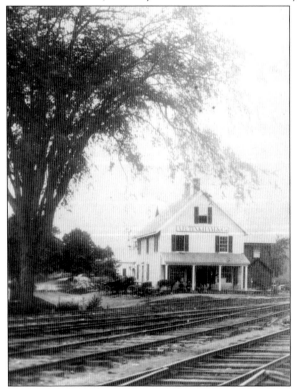

In several instances, the earliest commercial establishments in White River Junction were located in converted former farmhouses, as is the example shown here. A. B. Tinkham and Company maintained this store, shown about 1869, at the area of the village later referred to as Railroad Row. (Courtesy Hartford Historical Society.)

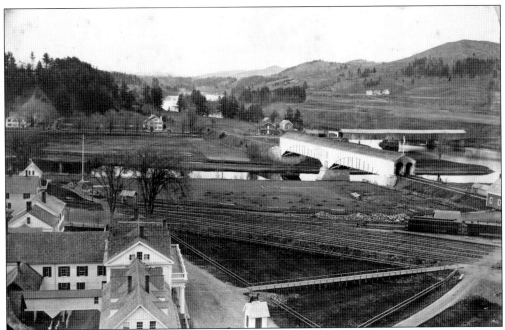

Both of the photographs on this page were made looking from the top of the gravel embankment in 1862. This view looks northeasterly and shows the first Junction House in the foreground, today the site of the Hotel Coolidge. In the midground is the Connecticut and Passumpsic Rivers Railroad bridge over the White River. (Courtesy Vermont Historical Society.)

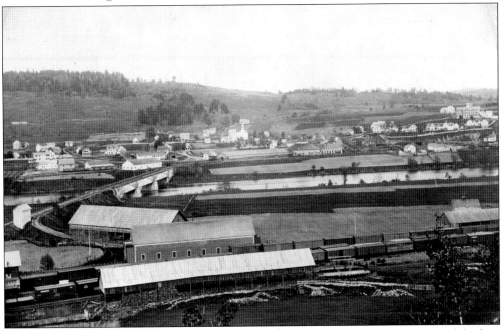

Of the three railroad-related buildings in the foreground of this view, two are large wood sheds to supply fuel for the early steam locomotives. The middle building is an engine house for servicing the locomotives. Note the early turntable at right. In the background are West Lebanon and the Connecticut River bridge. (Courtesy Dartmouth College Special Collections.)

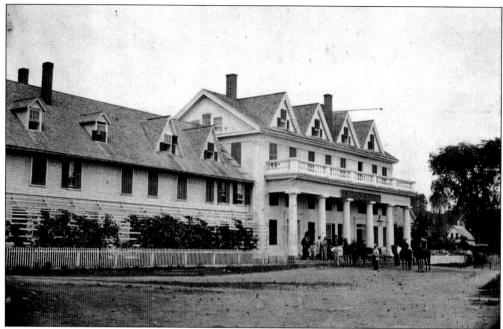

Col. Samuel Nutt, a former successful riverboat operator and large landowner in the new railroad community, constructed the first railroad hotel called the Junction House. Originally, the building stood in Enfield, New Hampshire, and was known as the Grafton House. Nutt purchased the building, dismantled it, and moved the pieces by rail to White River Junction in 1849. (Courtesy Dartmouth College Special Collections.)

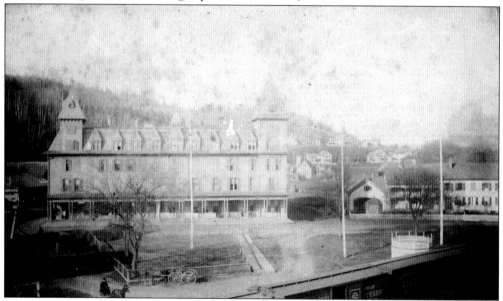

In August 1878, the first Junction House hotel was completely destroyed by fire. On the same site, by 1879, a new Junction House had been erected, designed in the then-fashionable "French" or Second Empire style. This view of the building taken shortly after completion shows the area in front, adjacent to the tracks, when it was a low depression of ground, often used as a dump. To the right is the Gates House. (Courtesy Vermont Historical Society.)

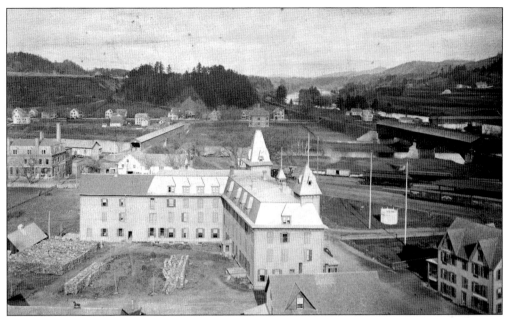

This photograph, taken in 1884, looks from about the same vantage point as an earlier view shown on page 63. In addition to the new Junction House in the foreground, it also illustrates how the young railroad community was starting to mature and spread out on both sides of the White River. New commercial buildings, a school, and a highway bridge now appear. (Courtesy Hartford Historical Society.)

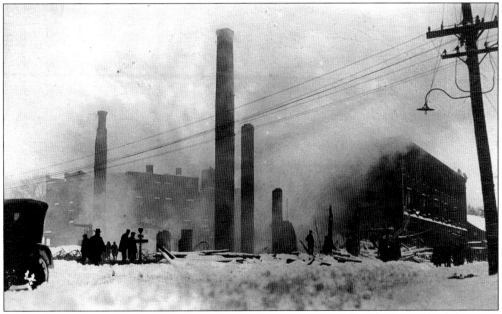

After 46 years of continuous service, the second Junction House, called the Hotel Coolidge since 1924 in honor of Pres. Calvin Coolidge's father, John, of Plymouth, completely burned. The fire started shortly after 5:00 p.m. on January 29, 1925, and by the following day after a spectacular nighttime fire, it was a total loss. The popular hotel was owned by Nathaniel P. Wheeler at the time. (Courtesy Hartford Historical Society.)

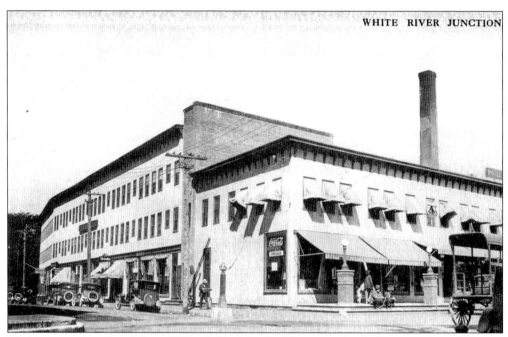

Within several weeks of the old Hotel Coolidge building completely burning, the rubble was cleared away, and a new building was erected on the foundations of the former structure. To get the new hotel into operation as quickly as possible, the initial front building was only two stories tall, as shown here in the summer of 1925. (Courtesy Hartford Historical Society.)

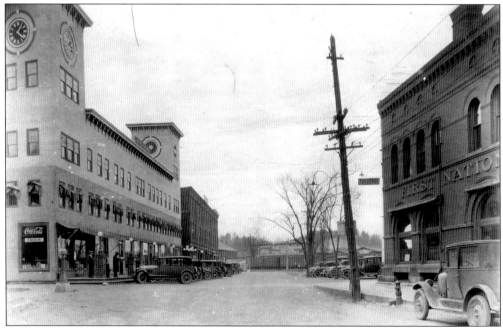

By the following year, the third floor was added to the new Hotel Coolidge, shown here as it appeared in 1926. The rebuilt facility had 160 guest rooms and two towers to acknowledge the old building destroyed a year earlier. A brick veneer was later added to the building. (Courtesy Hartford Historical Society.)

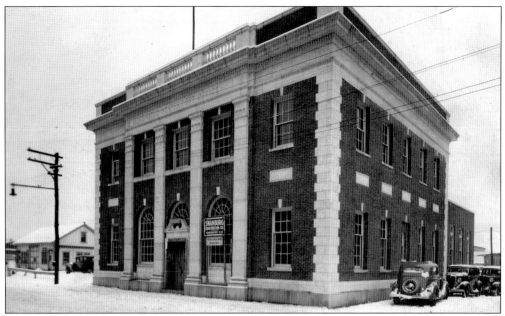

White River Junction obtained its first post office in 1850, located in Col. Samuel Nutt's home on South Main Street. However, it was not until this facility was constructed in 1934 that the village post office had its own building. This facility, a Works Progress Administration project completed during Pres. Franklin D. Roosevelt's administration, was opened in the spring of 1935 and was closed after completion of the new Sykes Avenue facility in October 1964. (Courtesy Hartford Historical Society.)

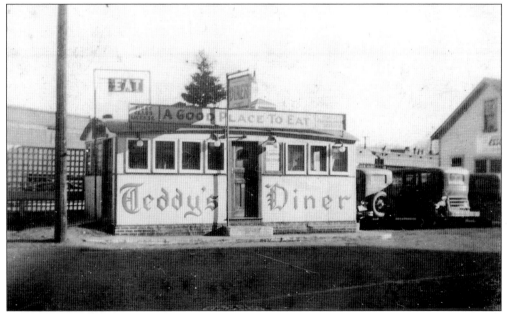

It is Christmastime 1934, and Teddy's Diner has its Christmas tree up and decorated—on the roof of the diner. Teddy Theriault and his wife, Grace, were enterprising folks who kept several diners within downtown White River Junction during the Great Depression. This facility was located across South Main Street from the Gates Block. (Courtesy Hartford Historical Society.)

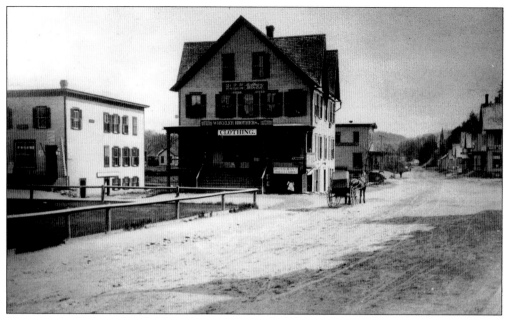

This view looks down South Main Street in the early 1880s and shows the first building to stand on the southeast corner of Gates and South Main Streets, the present site of the brick bank building. One of White River Junction's first commercial buildings, it was moved in 1892 to make room for the bank. (Courtesy Vermont Historical Society.)

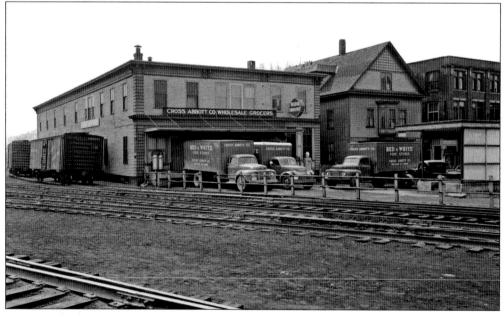

In 1894, Charles A. Cross of Fitchburg, Massachusetts, and Charles C. Abbott of Keene, New Hampshire, leased land from the Central Vermont Railway on which they constructed this wholesale grocery distribution business. This photograph shows the business in about 1950. In the 1960s, it was home to White River Paper, and today it is the location of Vermont Salvage Company. (Author's collection.)

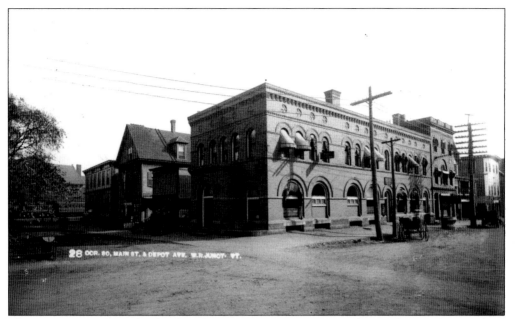

The First National Bank of White River Junction was organized on February 6, 1886, by a group of local businessmen. By 1891, the bank had purchased the property at the corner of Gates and South Main Streets, and after moving away the old wood-frame commercial building, it occupied this new state-of-the-art brick facility in May 1892. (Courtesy Dartmouth College Special Collections.)

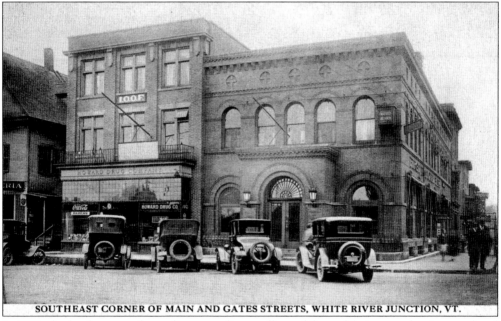

SOUTHEAST CORNER OF MAIN AND GATES STREETS, WHITE RIVER JUNCTION, VT.

In 1915, the bank removed an adjacent earlier small wood-framed fruit store that it owned and in its place constructed this new commercial block. The ground floor was occupied by Howard Drug Company's store, and the upper floor was home to the local chapter of the Independent Order of Odd Fellows. This postcard view was made about 1925. (Author's collection.)

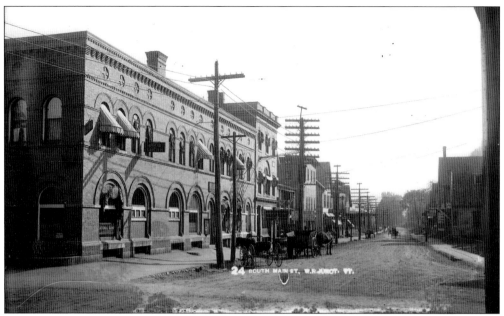

By the early 20th century, when this photograph was taken looking down South Main Street, this area of White River Junction had grown into a thriving community of commercial and multifamily buildings and uses. And like many faster-paced semi-urban areas in Vermont, it was beginning to attract a new immigrant population—in Hartford's case, many Italian families. (Courtesy Hartford Historical Society.)

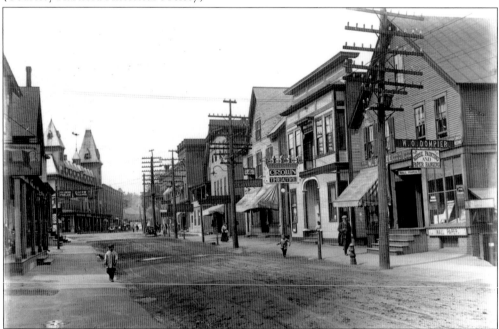

This image looking north on South Main Street, perhaps taken the same day as the photograph above, shows a vibrant commercial/residential neighborhood and the Junction House in the background. Close inspection reveals the presence of several very early automobiles in front of the hotel. (Courtesy Dartmouth College Special Collections.)

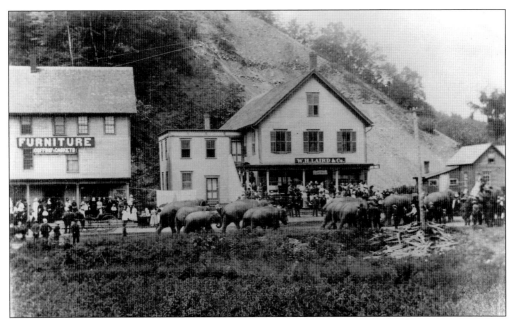

During midmorning on August 11, 1882, thousands lined the streets of White River Junction to watch the Barnum and London Circus parade prior to the show's setup in Col. Samuel Nutt's meadow on South Main Street. The great show arrived in 55 railroad cars. This view also shows the village hall, located above W. H. Laird and Company, in a building that predated the railroads. (Courtesy Hartford Historical Society.)

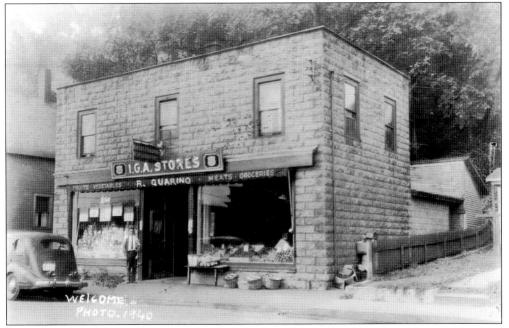

About 1922, Giachino Romano constructed this concrete masonry grocery store addition to the front of his house. However, several years later, he sold the property to Raffaele and Virginia Guarino. For the next 21 years, the Guarinos operated their Italian market until selling it in 1946 to Ralph "Babe" Falzarano and Fred Gobeille. (Courtesy Hartford Historical Society.)

Gates Street evolved during the 1870s from an alleyway behind the Junction House hotel leading to livery stables to an established part of the village with businesses, churches, and residences. This view, taken about 1880, shows Southworth's Livery Stable; the newly erected Methodist church, completed in the fall of 1878; and several new homes beyond. (Courtesy Vermont Historical Society.)

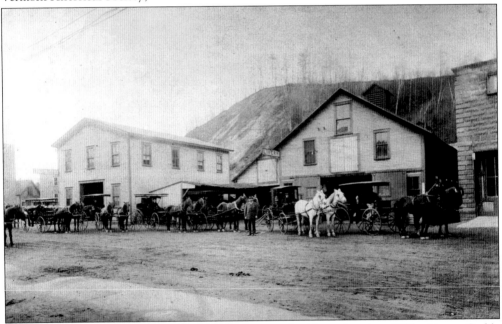

By about 1910, when this image was taken, newer buildings housing Gibbs Livery Stable had been constructed. In addition to the horse-drawn business, Lyman Gibbs added a Ford automobile agency to the operation in 1912. To the far right is the corner of Miller Automobile Company's new concrete masonry building, constructed about 1907. (Courtesy Hartford Historical Society.)

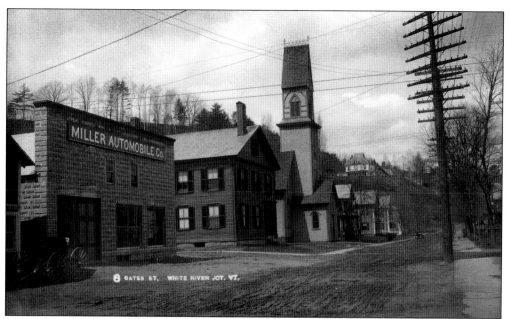

Looking up Gates Street about 1915, the area is looking well settled and established. Miller Automobile Company's successful Cadillac dealership is in the foreground. Next door is Mae Gate's old house, moved to this location in 1890 when she had the three-story brick block on Main Street constructed. Beyond are the Methodist church and several residences. (Courtesy Hartford Historical Society.)

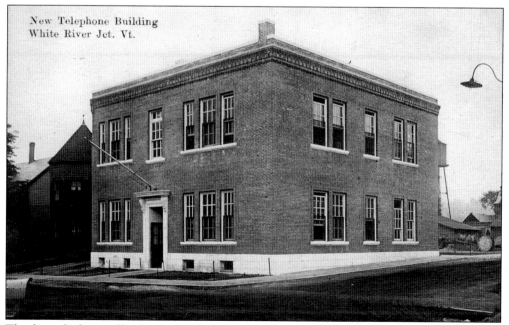

The first telephone office in White River Junction was established in the Junction House hotel in October 1894 with 25 subscribers. Rapid growth and other rented locations necessitated the construction of this state-of-the-art facility in 1922 at the corner of Gates and Currier Streets. (Author's collection.)

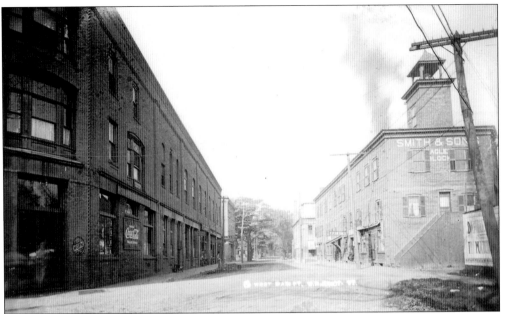

From the intersection of North and South Main Streets, this view from about 1915 looks west on North Main Street. To the left is the Gates building and opera house, constructed in 1890. The early history of the building on the right is not clear; however, it was probably constructed in the 1880s. It burned on March 6, 1949, and was by then known as Teddy's Hotel and Grill. (Courtesy Hartford Historical Society.)

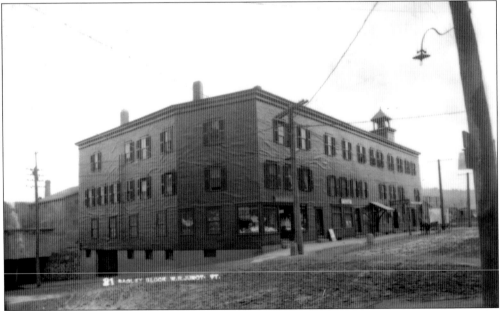

Of similar vintage as the view above and by the same photographer, this image looks east from the intersection of North Main and Bridge Streets at the then-called Bagley Block. This curious wood-framed commercial block, wedged between the street and railroad tracks, was for many years clad with sheet metal and later covered with artificial brick. (Courtesy Dartmouth College Special Collections.)

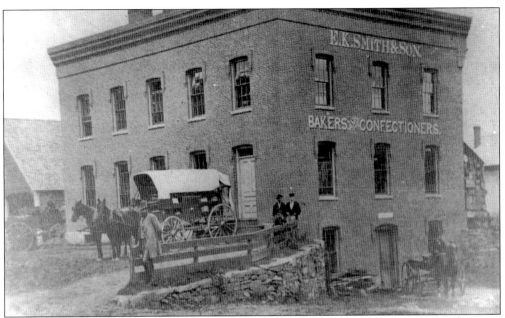

George W. Smith, owner of his family's cracker and confectionery business located in Hanover, New Hampshire, soon came to realize the benefits of the railroads for transportation of both raw material and finished products. Therefore, after relocating to White River Junction, he constructed this new facility in 1871, adjacent to both the railroad and the west side of Bridge Street. (Courtesy Hartford Historical Society.)

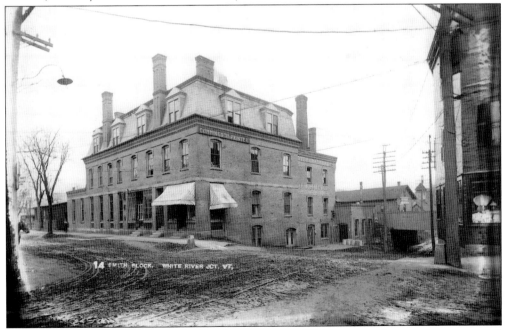

A fire did considerable damage to the Smith operation in 1884; however, that year he constructed this new block in front of the earlier 1871 building shown above. Located at the northwest corner of North Main and Bridge Streets, the buildings were razed in 1942. (Courtesy Hartford Historical Society.)

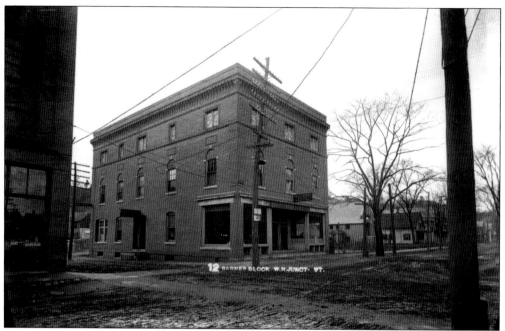

The White River Paper Company, organized by local businessmen, began in 1881. In 1907, after operating from several different locations, the company moved into the recently constructed Barnes Block, shown here about 1910. To the left is a corner of the large Gates Block. (Courtesy Dartmouth College Special Collections.)

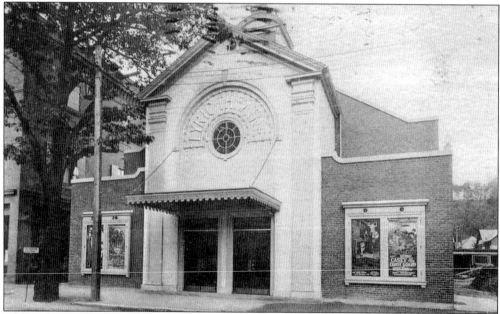

Although not the first movie theater in White River Junction, when the new Lyric Theatre opened in January 1924, it was as modern and spacious as any in the area. It was built and operated by Allard Graves from St. Johnsbury, and he sold the premises about 1965. In 1970, it permanently closed. The theater was razed in 1973 for a new telephone company business office building. (Author's collection.)

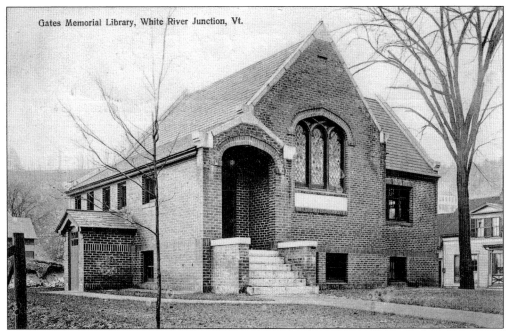

Gates Memorial Library, White River Junction, Vt.

The Gates Memorial Library was the result of a gift of land and funds from Amos Barnes of Boston, Massachusetts, in memory of George W. Gates and his family. Prior to the building's completion in April 1907, efforts at maintaining a library within White River Junction were difficult, as the library association had no permanent home. (Author's collection.)

The Vermont Baking Company was organized in 1897, and by 1899, it came under the control of E. K. Smith and Son (see page 75). In 1910, it became necessary to construct this modern and spacious bakery facility on North Main Street. By 1945, the facility was owned by the Ward Baking Company, and Tip Top Bread was baked there. (Courtesy Vermont Historical Society.)

This wintry scene looks west on North Main Street around 1900 from about the intersection of Bridge and Courier Streets. To the right is the 1884 building of E. K. Smith and Son, makers of crackers and candies. Utility poles, mature trees, and even the presence of a fire hydrant provide an established urban look. (Courtesy Hartford Historical Society.)

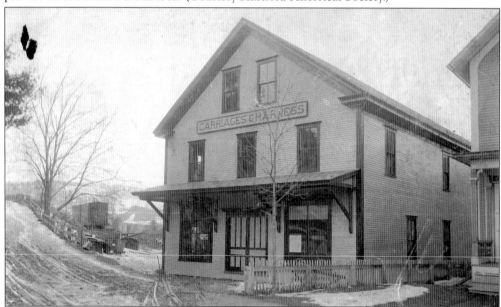

Henry R. Miller of North Hartland moved his established carriage business to White River Junction after taking on the Excelsior Carriage Company line of horse-drawn vehicles. In 1895, he erected a new facility on North Main Street. His son Garfield "Dusty" Miller formed Miller Automobile Company at this location in 1907. (Courtesy Hartford Historical Society.)

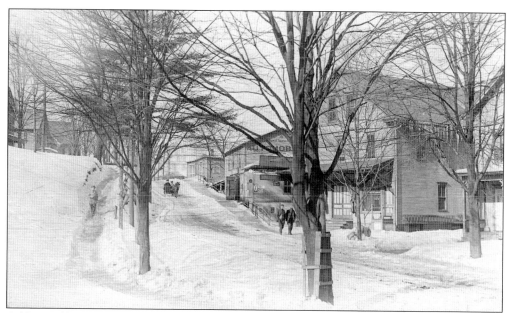

Additional buildings were constructed by the time this 1910 wintry view was taken. Also by this time, the Excelsior Carriage Company of Watertown, New York, had closed, and the Millers were selling Oakland and Stanley Steamer automobiles in addition to Cadillac and other lines from the North Main Street location. Note the new residential development to the upper left. (Courtesy Hartford Historical Society.)

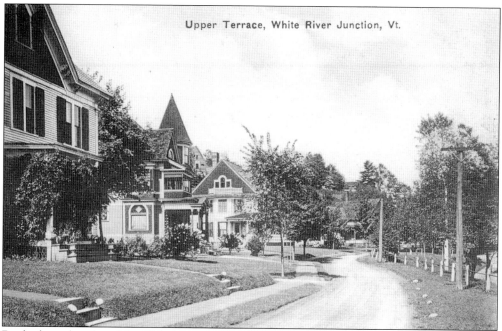

By the later decades of the 19th century, White River Junction grew from a newly created rough railroad town to a refined and established community with an emerging solid middle class. As a result, stylish and comfortable homes were constructed along the upper terraces overlooking the business district below. (Author's collection.)

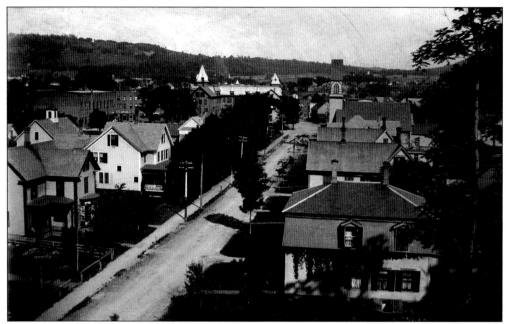

The west end of Gates Street, seen here about 1900 looking east from the upper terraces, was the first area of White River Junction to be transformed from farm fields into a residential neighborhood starting in the 1870s. By 1900, three churches were located in this neighborhood as well. (Courtesy Hartford Historical Society.)

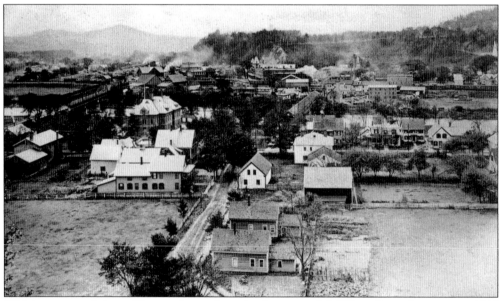

Within a span of about 65 years from when the first train left White River Junction in 1848 to when this image was taken looking south on the village in 1912, an area of three family farms had become one of the most important railroad hubs in northern New England. (Author's collection.)

Four

WEST HARTFORD AND THE WHITE RIVER VALLEY

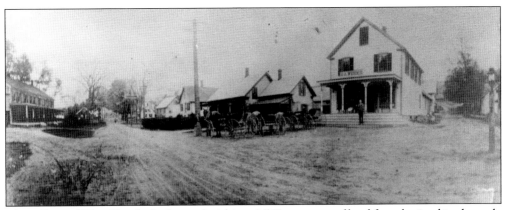

The village of West Hartford is located within a 1,560-acre area of land first obtained in the early years of Hartford's settlement by Thomas Hazen. Within decades, a small settlement had taken hold with a sawmill, bridge crossing, tavern, and general store, as seen in this early view looking west along what is now Vermont Route 14. (Courtesy Hartford Historical Society.)

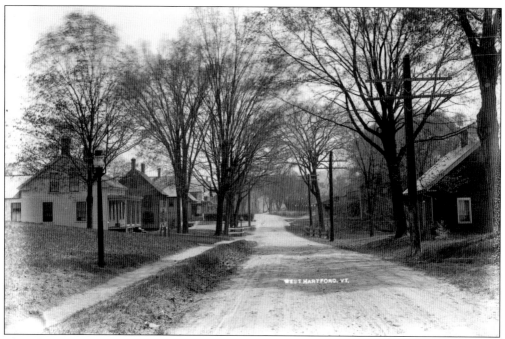

This photograph looks east down the main street of West Hartford Village. By the time it was taken, around 1910, telephone lines clearly had worked their way up the White River valley. Note too that the village could boast gas streetlamps. In the far distance is the end of the covered bridge also shown on page 85. (Courtesy Dartmouth College Special Collections.)

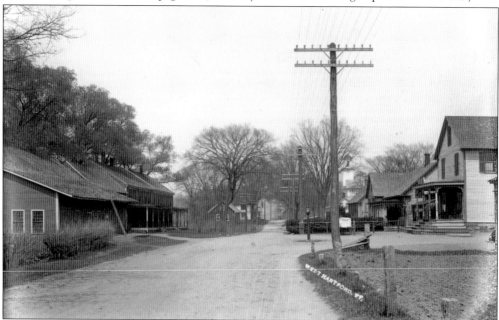

Probably taken the same day as the image above by the same photographer, this view looks west along the main street from about opposite the covered bridge over the White River to the left. To the right is the general store and post office. (Courtesy Dartmouth College Special Collections.)

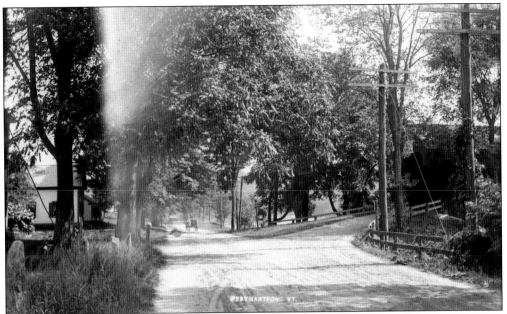

The White River Turnpike, charted to pass westerly through West Hartford Village in November 1800, ran remarkably straight along the north bank of the White River. Within the village area, early fords and ferries across the river provided highway connections with Woodstock and Pomfret prior to the first bridge constructed in 1820. (Courtesy Dartmouth College Special Collections.)

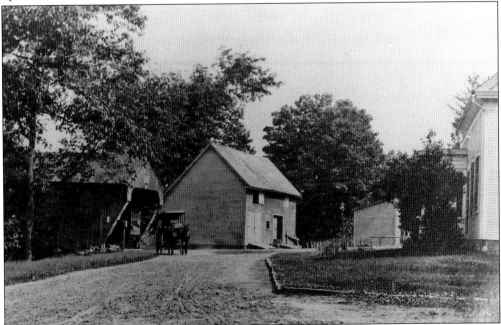

With the establishment of fords and ferries across the river at West Hartford, then followed by a bridge connection, local stage lines ran between this village and the Pomfret and Woodstock area. One of those stages is seen here about 1910 coming out of the south end of the bridge, probably carrying mail and freight in addition to passengers. (Courtesy Hartford Historical Society.)

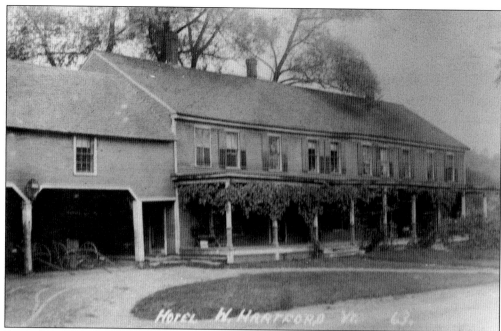

Records indicate that as early as about 1790, Francis W. Savage built and kept a hotel in West Hartford. The hotel seen here, opened by Alvan Tucker in 1838, was converted from an old house and brewery located next to the bridge and beside the main street and river. Pictured about 1910, it burned in 1924. (Courtesy Hartford Historical Society.)

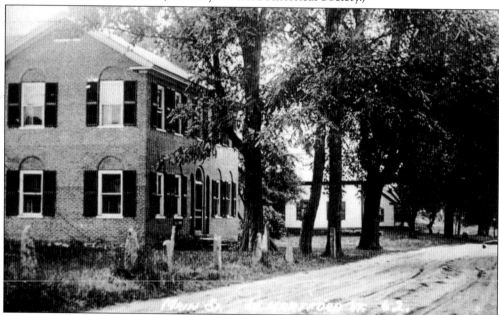

Although the West Hartford area never had the wealth made possible with larger-scale manufacturing or merchandising, it once boasted several substantial homes like this early-19th-century brick house. However, this stately residence was critically damaged by the November 1927 flood. Today the village library occupies the site (see page 87). (Courtesy Hartford Historical Society.)

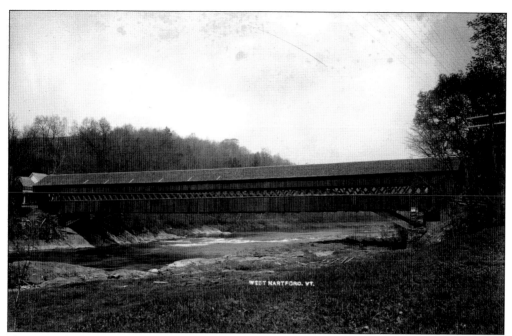

West Hartford's first bridge over the White River was erected in 1820, an open king post affair lasting only seven years. A second bridge survived until it was swept away by floodwaters in 1867. This fine structure, erected that year by notable bridge builders James Tasker and Bela Fletcher, cost $6,110.79 when completed. (Courtesy Dartmouth College Special Collections.)

The November 1927 flood was especially devastating to West Hartford, and a nearby house was swept into the raging river and slammed into the covered bridge, causing its destruction. Until a new steel replacement bridge was erected the following year, that winter, a temporary ferry was put into service crossing the White River. (Courtesy Hartford Historical Society.)

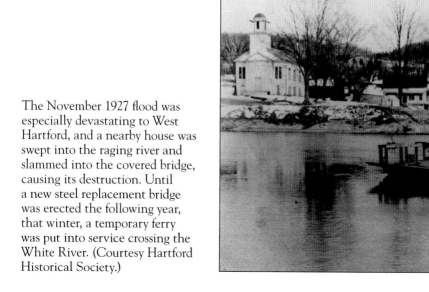

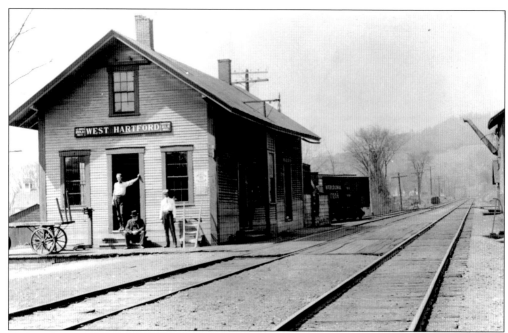

As soon as regular service was established on the Vermont Central Railway in June 1848, West Hartford Village became a scheduled stop for both freight and passenger service. This westerly looking view from about 1900 shows the depot, several sidings, and water tank facilities to supply the steam locomotives. (Courtesy Hartford Historical Society.)

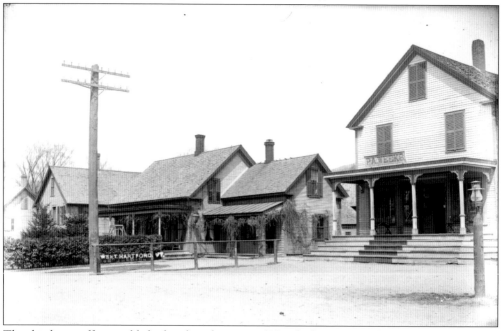

The third post office established within the town of Hartford was in April 1830 at West Hartford and typically was housed within one of the village's several general stores. Mail deliveries were first by stage and then later by railroad. This view from about 1910 is of the P. A. Weeks store, located on the north side of the main street. (Courtesy Dartmouth College Special Collections.)

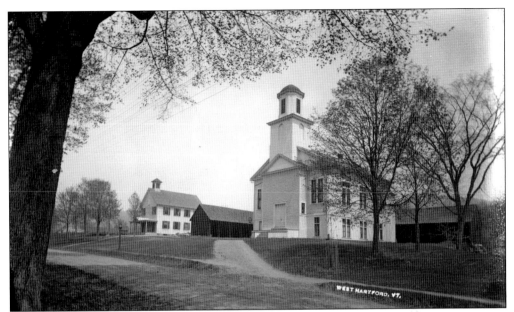

West Hartford organized its first school in 1795, and until the building was erected in 1884, shown to the left of this photograph from about 1910, accommodations were less than ideal. The Congregational Society organized in January 1829 and erected this facility in 1832. In 1860 and 1884, renovations were made to the building that has not been regularly used since 1961. (Courtesy Dartmouth College Special Collections.)

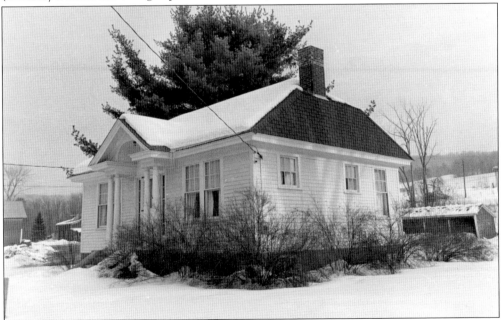

After reading of the tragic damage to West Hartford and the complete loss of the village's library in the November 1927 flood, the citizens of Hartford, Connecticut, organized the Hartford to Hartford Committee to raise funds for a new library. The site of a critically damaged home was selected (see page 84), and by 1929, this new facility was constructed. (Courtesy Hartford Historical Society.)

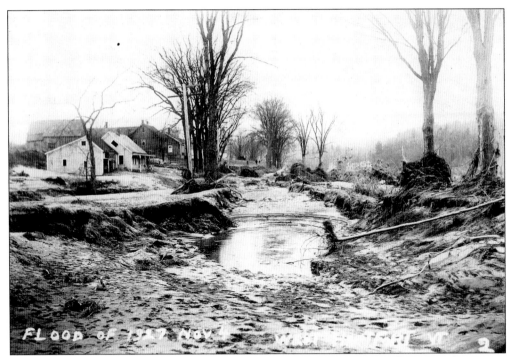

October 1927 saw excessive amounts of rainfall, and on November 2, phenomenal amounts of rain started to fall again. By the evening of November 3, the main street of West Hartford became impassable, and people began leaving their homes, some seeking refuge at the railroad depot located on higher ground. (Courtesy Hartford Historical Society.)

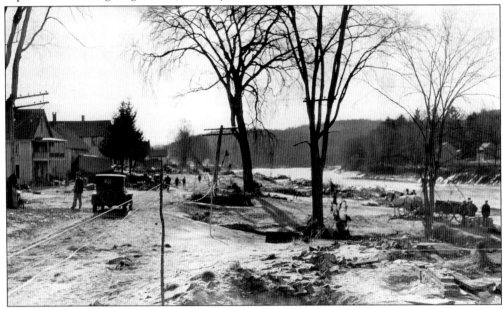

During the night of November 3, seven residences within the village, along with their barns and other outbuildings, were completely carried away by the raging floodwaters. The village was almost wiped out. No lives were lost in West Hartford, but two perished downstream in White River Junction. (Courtesy Hartford Historical Society.)

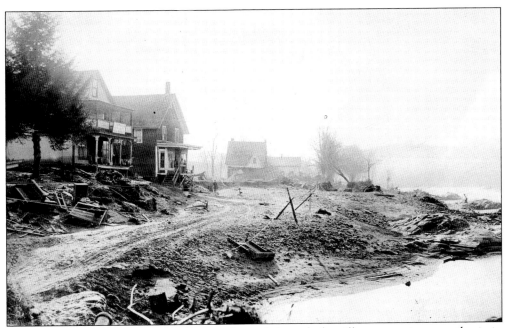

The rampaging White River carved a new channel through the village, sweeping away the main street and all buildings between it and the river as well as the covered bridge. This east-facing view shows the village's two general stores. Compare these views with those of the village earlier in this chapter. (Courtesy Hartford Historical Society.)

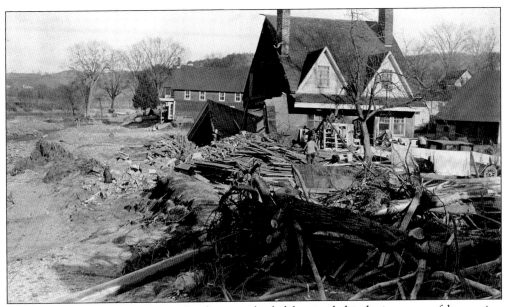

Following November 4, the raging floodwaters subsided, leaving behind grim scenes of destruction like the above. Soon scores of Dartmouth College students arrived in the village and played a major role with the cleanup. Beyond is one of the village's general stores. (Courtesy Hartford Historical Society.)

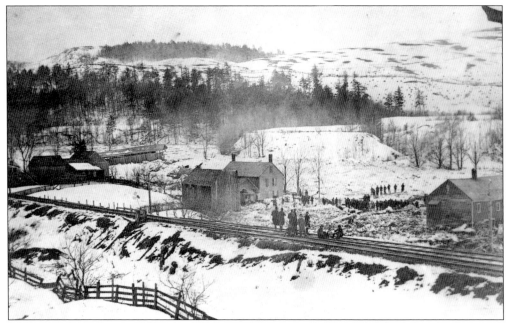

As devastating as the November 1927 flood was to West Hartford, it was not the first. On February 10, 1867, rain followed several very warm days, and at 7:00 a.m., about a mile above the village, the ice began to break up. This scene, looking south from above the village, shows the covered bridge lying smashed in the meadows beside the river. (Courtesy Hartford Historical Society.)

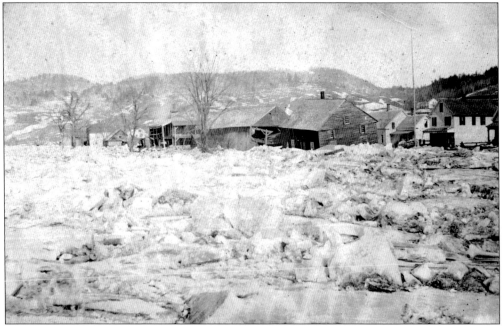

This view of the ice jams and resulting flood looks at the village from the south side of the river where the bridge formerly stood. Backed-up water flooded nearly every building within the village, and one life was lost. To the right are the two general stores. (Courtesy Dartmouth College Special Collections.)

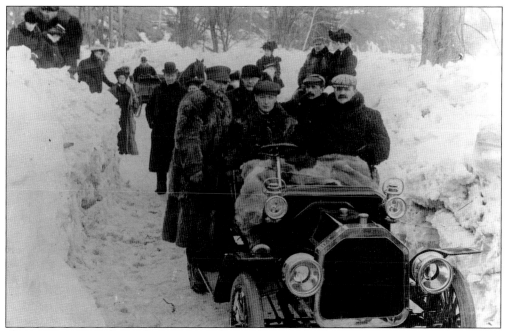

Fluctuations in weather and temperature during the winter of 1908 caused massive ice jams along the White River between West Hartford and Hartford Village. This view shows several young sports in their two-cylinder Buick motoring through the aftermath of the Saturday, February 15 jam. (Courtesy Hartford Historical Society.)

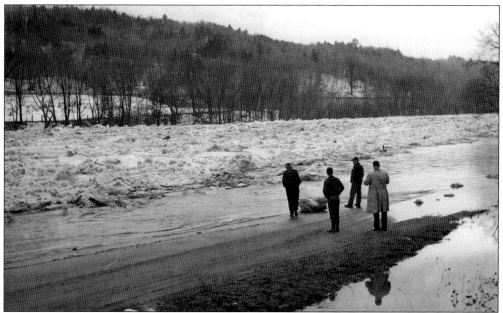

Lest one thinks that ice jams in the White River only occurred before the age of modern highway construction, this image shows Vermont Route 14 at the Jericho Road intersection and the April 3, 1959, ice jam. Prior to the construction of Interstate 89, this was the main route into central Vermont from the Upper Connecticut River valley. (Courtesy Hartford Historical Society.)

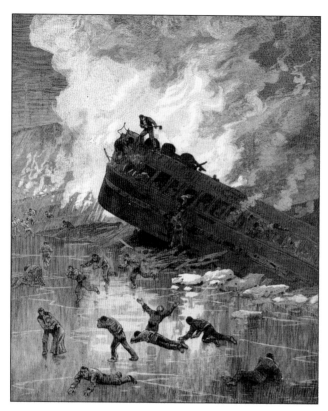

At 2:10 a.m. on the frigid night of February 5, 1887, the night express bound for Montreal began crossing the wooden railroad bridge spanning the White River. The end car, a sleeper, derailed just before the bridge, and once it was on the trestle, it fell 43 feet onto the ice, taking three other cars with it. Upon hitting the ice, the cars burst into flames, igniting the wooden bridge as well. (Author's collection.)

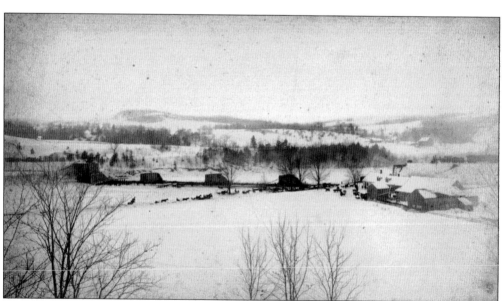

The remainder of the train made it to the north end of the bridge, which soon became fully engulfed in flames. By morning, when this image was made, 31 persons were known to have perished in a horrible death and 49 others were injured. A temporary morgue was quickly set up in nearby Hartford Village, as spectators and photographers flocked to the scene. (Courtesy Hartford Historical Society.)

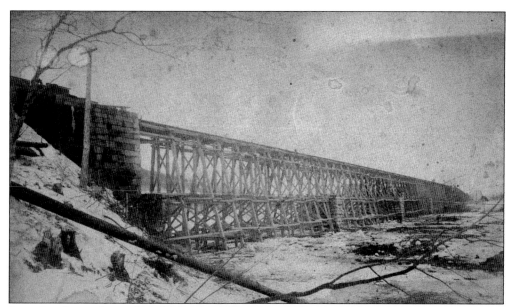

Immediately in the wake of what was the worst railroad accident in Vermont history, a temporary wooden trestle was erected to replace the destroyed bridge. Evidence of the disaster was still visible on the ice when this photograph was made. Several years later, laws were enacted nationwide banning open flames inside railroad cars for heating and lighting. (Courtesy Hartford Historical Society.)

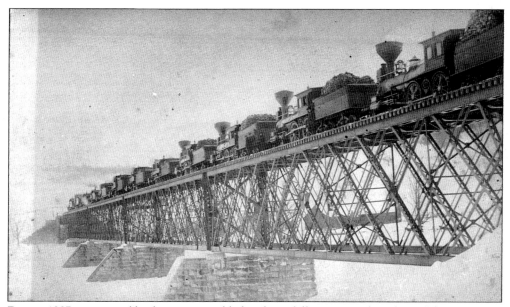

During 1887, a new steel bridge was assembled and carefully positioned in place of the temporary wooden trestle. At 650 feet, this was the longest railroad bridge in Vermont, and on January 15, 1888, the completed new span was tested with 12 locomotives at a combined weight of 854 tons. The new bridge was constructed with 440 tons of iron. (Courtesy Hartford Historical Society.)

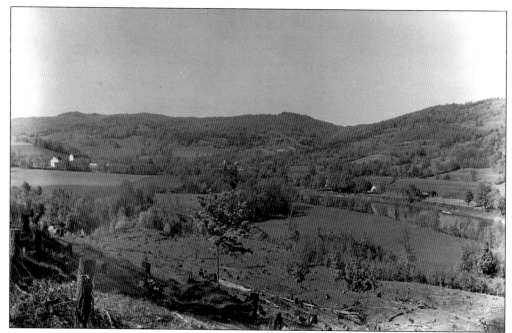

By the 19th century, agriculture and family farms became an established way of life for many within the White River valley and remained so well into the 1950s. This panoramic view of the valley was made about 1910 near West Hartford by White River Junction professional photographer George E. Fellows. (Courtesy Dartmouth College Special Collections.)

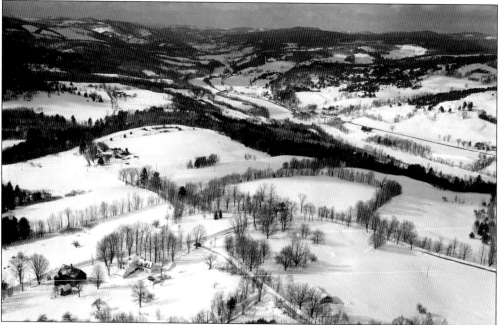

Taken more recently than the White River valley image above, this view from about 1960 looks northwest from almost over the present-day Quechee exit of Interstate 89. In the center distance is the infamous Hartford railroad bridge. In the mid-1960s, Interstate 89 began carving its path northward through this quite rural vista. (Courtesy Vermont Historical Society.)

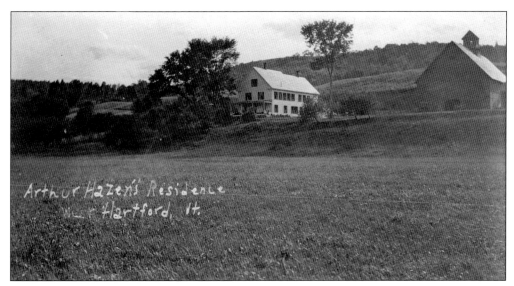

The Hazen family was among the earliest settlers within the White River valley of Hartford, and for many generations, numerous hillside farms were owned by generations of Hazens. During the last two centuries, railroad and then highway construction fractured many of these valley farmsteads. (Courtesy Hartford Historical Society.)

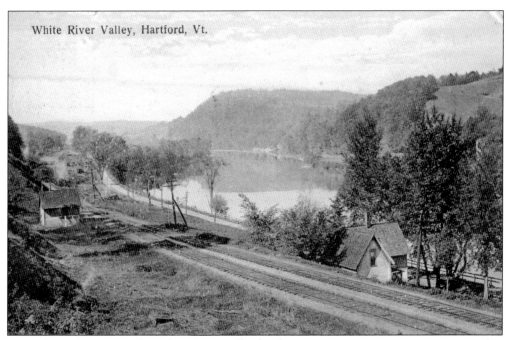

Since the earliest times, the White River valley has been an important transportation corridor. Native Americans used the river for passage between the Connecticut River and the Green Mountains. Early white settlers walked along the riverbanks and later constructed the first crude dirt path turnpikes. In 1848, they constructed the first operable railroad in the state of Vermont along its banks. (Author's collection.)

The State of Vermont's biennial report for 1921 and 1922 marked the beginning of an active decade of road building and an integrated state highway system. In 1925, the federal government established the still-current road numbering system. About the same time, Vermont numbered primary highways. The old White River Turnpike became Vermont Route 14, a major area highway. (Author's collection.)

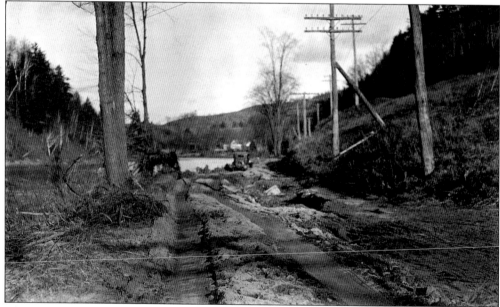

The great flood of November 1927 caused more than $7 million of damage to the state's highways and bridges, and of the latter, 1,258 were destroyed. Route 14 through Hartford, running along the White River, was heavily damaged and for a time not passable. As a result, travel into the interior areas of the state was critically limited. (Courtesy Hartford Historical Society.)

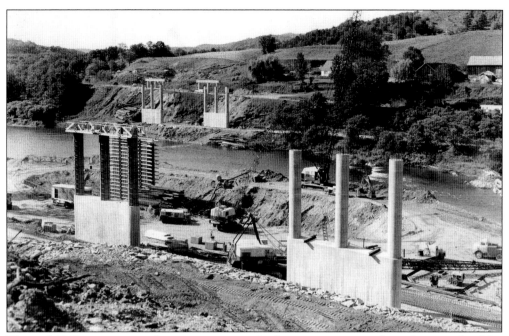

The mid-1960s was a time of massive interstate highway construction throughout much of the town of Hartford. On November 7, 1968, Interstate 89 was opened from White River Junction to Sharon. This view looks north across the White River in 1966 and shows the Interstate 89 bridge under construction. (Courtesy Hartford Historical Society.)

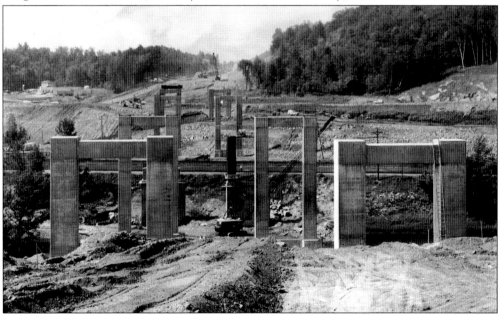

Just as the railroads linked up at White River Junction in 1848, so too did the interstate highway system 120 years later. On October 9, 1968, Interstate 91 was opened to Norwich after completion of the giant bridge spanning the Central Vermont Railway, the White River, and Route 14. This 1966 view of the bridge under construction looks south. (Courtesy Hartford Historical Society.)

In 1890, the Vermont State Fair began on land today known as the Sykes Avenue area. From 1900 until 1907, the fair was abandoned and then resumed until permanently closing in 1928. Special trains on a section of steep uphill tracks, now U.S. Route 5, were run, as evidenced in this view from about 1910 taken near the front main gate. (Courtesy Hartford Historical Society.)

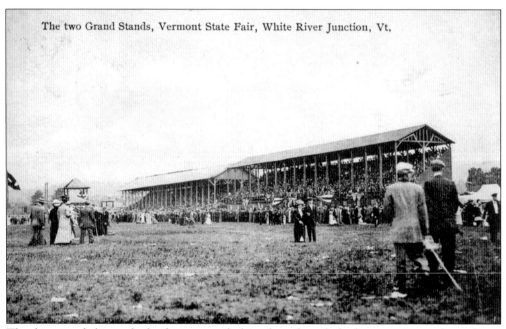

The fairgrounds boasted of a fine, one-mile kite-shaped track for horse racing and two large, wooden grandstands from which to comfortably watch all the action. In addition to the annual state fair, the track was used regularly throughout the year, and many horse racing records were set here. (Author's collection.)

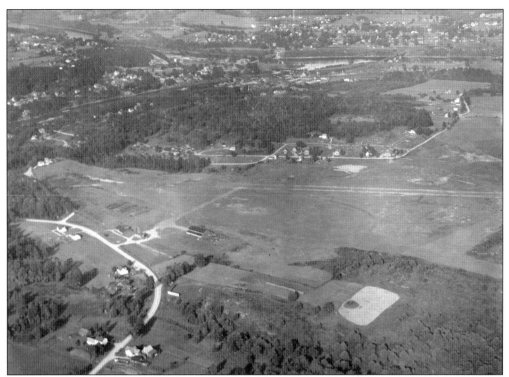

After the Vermont State Fair Association abandoned the Sykes Avenue site in 1928, it became the location of the Twin State Airport, dedicated July 4–6, 1929. A hard-surfaced 1,850-foot runway was added in 1934. The airport closed in 1950. In the lower left corner of this aerial view is U.S. Route 5. (Courtesy Hartford Historical Society.)

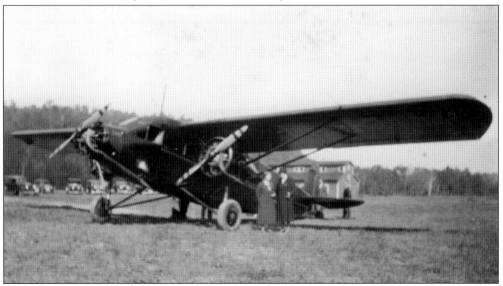

In 1933, famed aviator Amelia Earhart visited the Twin State Airport, seen here with her newest aircraft. In addition to occasional flying dignitaries, the regional airport provided airmail service out of White River Junction immediately after the November 1927 floods devastated much of the state's highway and rail infrastructure. (Courtesy Hartford Historical Society.)

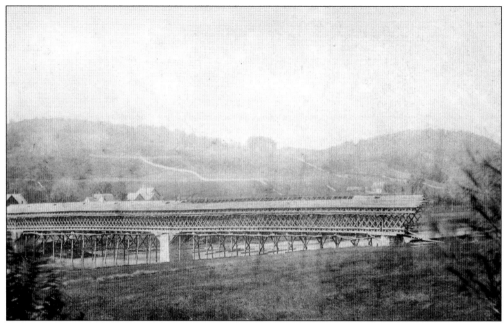

Prior to 1867, anyone wishing to cross the White River to reach White River Junction had to cross at Hartford Village, a detour of nearly four miles. That year, at a cost of $13,426.62, noted bridge builders James Tasker and Bela Fletcher erected the bridge seen here in a very rare construction photograph. (Author's collection.)

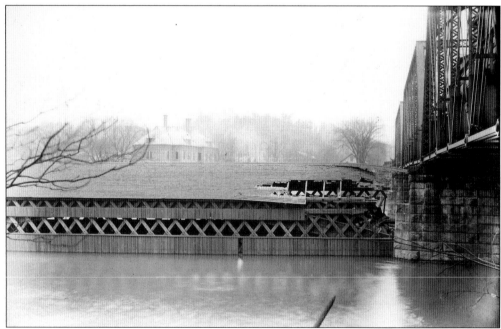

The big White River bridge served admirably until the March 1913 flood. At Sharon, 10 miles upstream, 2.5 million feet of logs being held back in the river by a boom broke loose. With waters at flood stage, the logs slammed into the bridge, knocking it off its abutments and slamming it into the adjacent railroad bridge. (Courtesy Hartford Historical Society.)

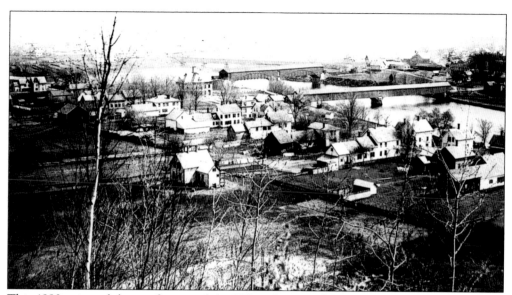

This 1880s view of the confluence of the White River and Connecticut River valleys shows how important and busy the area had become within a very short amount of time. Less than 50 years earlier, there was one bridge rather than four, a single-lane dirt highway, and family farms. (Courtesy Hartford Historical Society.)

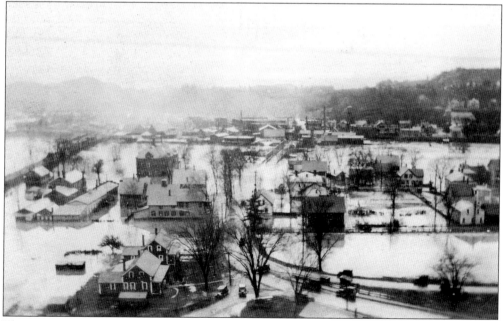

The convergence of the flooded White River and Connecticut River valleys on November 3 and 4, 1927, caused the turbid waters to rise more than two feet per hour. Within the junction area, much hardship, suffering, and damage ensued. All travel and communication came to a halt. (Courtesy Hartford Historical Society.)

The early 1920s brought about a sudden and increased amount of automobiles on the road in all regions of the country. Much of this increase was pleasure as well as business travel, and numerous new facilities sprung up to service the motoring public. Fogg's Filling Station was on busy Maple Street, also known as the major state highway Route 14. (Courtesy Hartford Historical Society.)

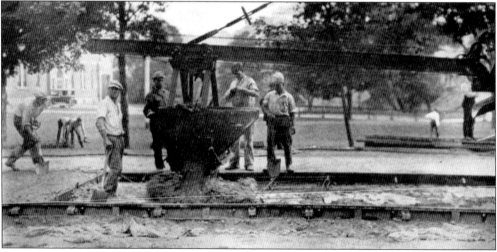

World War I brought about advancements in many types of machinery, and the 1920s in turn saw advancements in road construction technology. This all became necessary with the greatly increased popularity of the automobile. Here Maple Street is getting a makeover in 1923. (Courtesy Hartford Historical Society.)

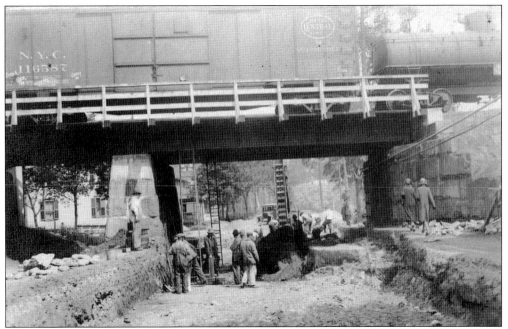

Part of the 1923 rebuilding of Maple Street, turning it into the major highway within the White River valley, included lowering the grade at the railroad overpass. The 1920s also saw the first common use of trucks, many carrying high loads. Note the train crossing above. (Courtesy Hartford Historical Society.)

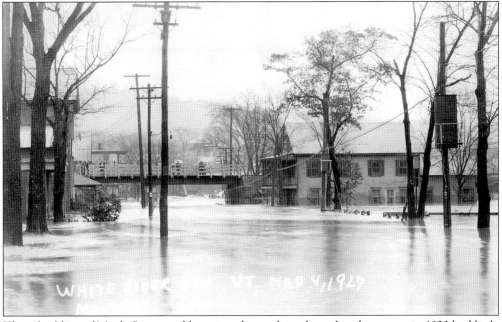

The rebuilding of Maple Street and lowering the grade at the railroad overpass in 1923 had little effect on the rampaging waters of the Connecticut and White Rivers during the November 1927 flood. Surprisingly, none of the highway infrastructure in White River Junction was seriously damaged. (Courtesy Hartford Historical Society.)

This photograph from 1930 looks northwest at the intersection of Pine Street (U.S. Route 5) and Maple Street (U.S. Route 4 and Vermont Route 14). The Lyman homestead, erected in 1796, was soon torn down to make way for a gasoline station, an indication of the times and the new automobile age. (Courtesy Hartford Historical Society.)

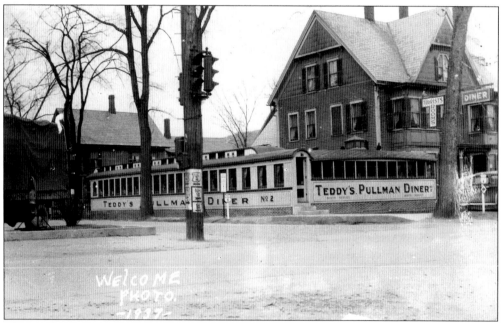

The northeast corner of the same intersection came to accommodate Teddy Theriault's diner in the 1930s, taking advantage of the crossing of two major regional highways at the intersection of two major river valleys. Also note that the fine Victorian-era home is now a tourist rooming house for motorists. (Courtesy Hartford Historical Society.)

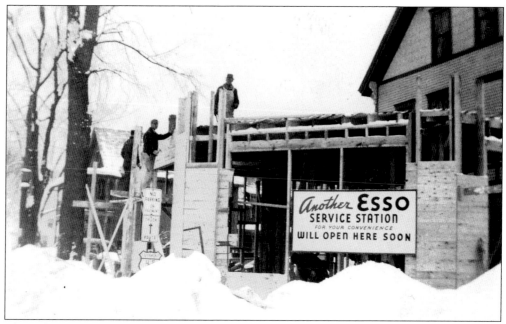

Throughout the 1930s, the major oil companies were purchasing sites at major intersections in order to erect gasoline stations. Apparently by 1939, Theriault thought it was worthwhile to give up this corner to Esso and relocate his diner elsewhere. (Courtesy Hartford Historical Society.)

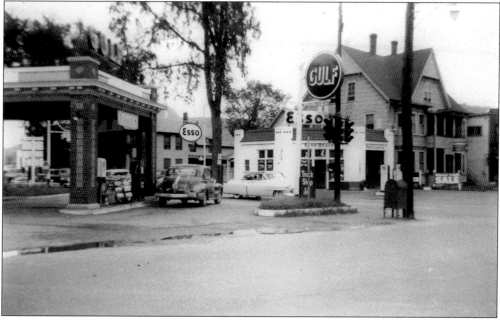

By 1953, when this photograph was made, Maple Street had become transformed from an established 19th-century residential neighborhood to a 20th-century commercial area centered around the automobile, catering to the traveling public passing along the White River valley corridor. (Courtesy Hartford Historical Society.)

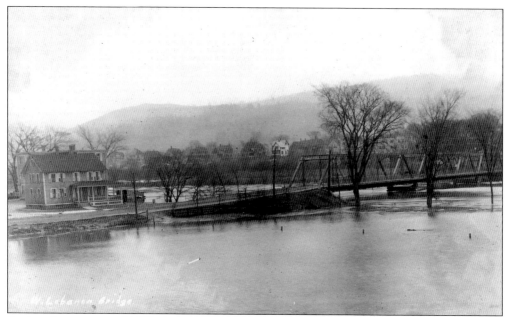

During the summer of 1895, the Lyman wooden covered bridge (see page 11), erected in 1836 between Hartford and Lebanon, New Hampshire, across the Connecticut River, was replaced by a new, modern steel truss structure. During the great flood of November 1927, as seen here, the bridge withstood the surging waters; however, after the March 1936 flood, it was replaced. (Courtesy Hartford Historical Society.)

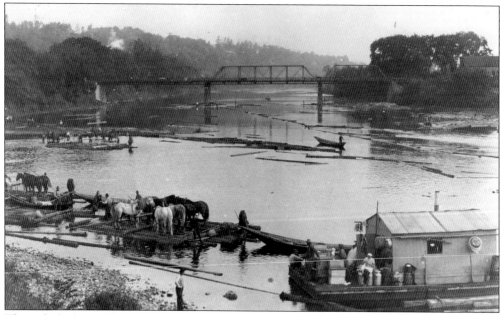

Through the late 19th century and into the early 20th century, both the White and Connecticut Rivers were utilized in the spring of each year to drive vast quantities of harvested logs south to sawmills located in Massachusetts. Here at the mouth of the White River, the rear of a 1914 log driver is passing downstream below the West Lebanon highway bridge. (Courtesy Hartford Historical Society.)

Five

OLCOTT, WILDER, AND THE CONNECTICUT RIVER

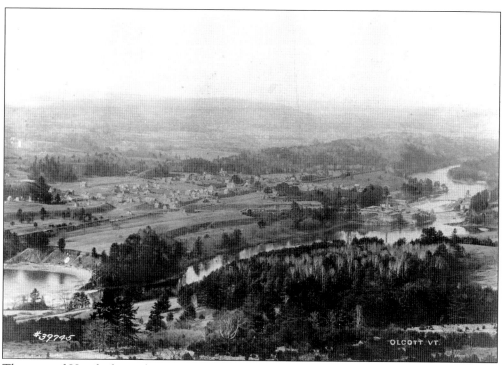

The area of Hartford now known as Wilder was the last village settlement to be established. First known as Olcott, due to canal locks on the Connecticut River, the name was changed to Wilder in December 1897. This view looks northerly down on the river and village area from New Hampshire in July 1895. To the lower left is the present-day site of Wilder Dam. (Courtesy Hartford Historical Society.)

Explorers of the Connecticut River valley encountered a series of three falls over a distance of about a mile as the river runs. Known as the White River Falls of the Connecticut River, this is the lower bar, now the site of Wilder Dam. By about 1790, some scattered settlements existed here on both sides of the river, and possibly an early gristmill was located on the Hartford bank. (Author's collection.)

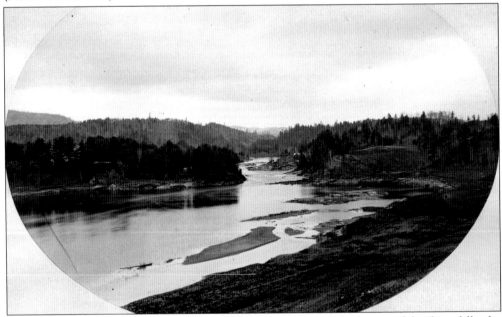

This photograph, taken in 1859, looks north up the river toward the largest of the three falls, the middle bar, located about half a mile above the lowest rapids. The total drop of the river over these first two areas of falls was 37 feet. Early river travel made it necessary to break bulk and then carry a mile and a half to get around this treacherous area. (Courtesy Dartmouth College Special Collections.)

This closer view looking upriver of the middle falls was made in 1882 just before redevelopment to harness the river's considerable waterpower. Native Americans found this area of the river abundant with salmon, and as a result it was a regular and favored location. By 1784, early saw- and gristmills were developed along the Hartford shore. The lay of the land required no more than simple wing dams during ordinary stages of water flow. (Author's collection.)

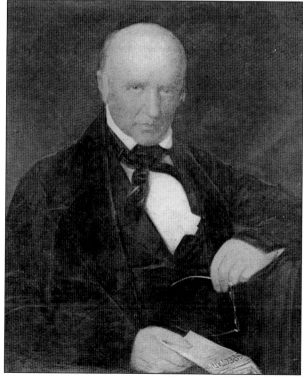

In June 1792, the New Hampshire legislature granted a charter to lock the falls for navigation. Nothing came of this effort until March 1806 when Hanover, New Hampshire, businessman Mills Olcott became involved. By 1810, the effort was completed, and Olcott had expended nearly $23,000 on the work. Olcott died in 1845 after 35 years successfully operating and owning the White River Falls Company Navigation Locks and Canal. (Author's collection.)

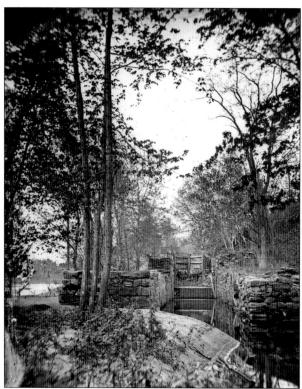

When placed into service in the spring of 1810, the canal system consisted of two locks at the lower falls and three at the upper falls. Each lock, made of stone construction with heavy wood timber gates, was fed with water diverted from the river by simple crib timber dams. The locks measured about 16 feet wide by 88 feet long, as shown in this view made long after the system was abandoned in 1848. (Author's collection.)

When completed, Mills Olcott's canal and lock operation was part of a river-long system, allowing freight to move from Hartford, Connecticut, to Wells River, Vermont. The largest flatboats were about 72 feet long by 11 feet in width and drew about three feet of water. A round-trip took about two weeks with as many as seven crew members, one on the rudder and six poling. (Courtesy Hartford Historical Society.)

BOAT ENTERING LOCKS.

This period engraving shows a smaller canal boat on the Merrimac River, similar to crafts used on the Connecticut River. Typically, wood products, furs, and farm produce were transported downriver, with iron and household goods brought back on the return voyage. The toll for a boat was $2, and in the first year, Olcott grossed $2,343 of income. (Author's collection.)

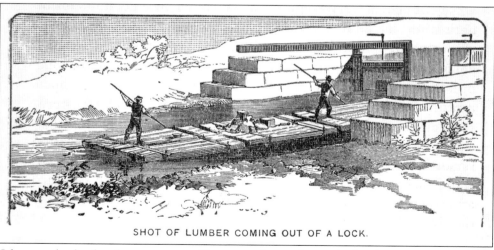

SHOT OF LUMBER COMING OUT OF A LOCK.

Often surplus lumber from area sawmills was made into boxes 60 feet long and 13 feet wide, sized to fit through the locks and canals. Floated to Hartford, Connecticut, product could be transferred to oceangoing vessels. For the drivers of these one-way lumber rafts, they returned to the Upper Connecticut River valley as best they could. (Author's collection.)

During 1848, thousands of Irish laborers worked with hand tools and dump carts constructing railroad tracks north from White River Junction along the Connecticut River. In October of that year, regular service began as far as Bradford, and the days of river float boats came to an abrupt end. (Author's collection.)

By 1880, all the assets, lands, charters, and riparian flowage rights of the Mills Olcott estate and others were formed into the new Olcott Falls Company by D. P. Crocker of Holyoke, Massachusetts. This view from about 1880 looks downriver at the middle falls, the area of Crocker's new holdings. (Author's collection.)

Crocker sold his river holdings to Charles T. and Herbert A. Wilder of Boston, and in 1882, they constructed a new dam at the middle falls. When completed in January 1883, the dam was 808 feet long, using 1.7 million feet of timber and 3,300 perches of stone. The construction cost was $50,000. (Courtesy Hartford Historical Society.)

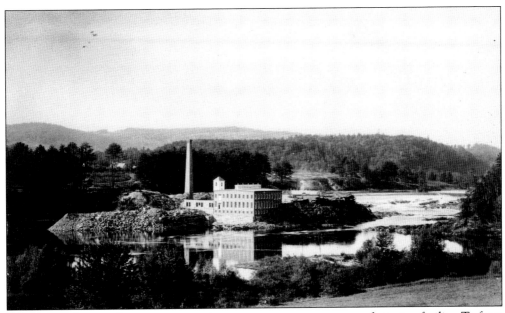

As the new dam was being constructed so too was a new paper manufacturing facility. To form the waterwheel pit alone, 12,000 cubic yards of stone ledge was blasted using 13,000 pounds of dynamite. Two 120-foot-long, 8-foot-diameter iron penstocks fed water to 11 waterwheels, generating 200 horsepower each. (Author's collection.)

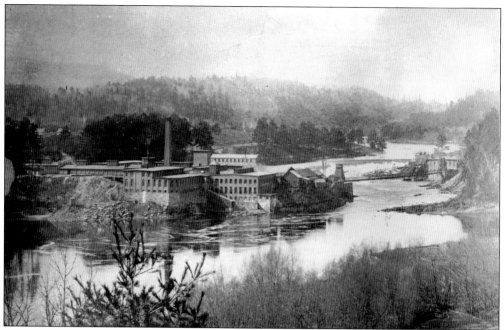

In 1888, additions were constructed to the paper mill located on the Vermont side of the river, and in 1890, a new pulp-grinding mill building was constructed on the New Hampshire side. Compare this view from about 1895 with that on page 108 taken about 35 years earlier in 1859. (Courtesy Hartford Historical Society.)

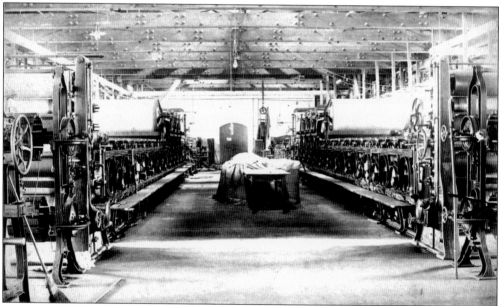

By the 1890s, the rapidly growing and very successful paper company established by the Wilders was running 24 hours per day, consuming 30 cords of wood and making 45 tons of wet pulp that in turn produced nine tons of newsprint per day shipped by railroad to urban area newspaper publishers. (Courtesy Hartford Historical Society.)

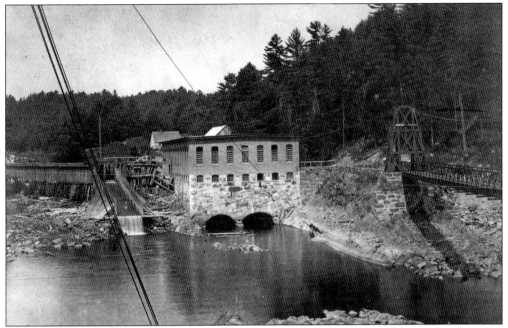

The pulp-grinding building finished in 1890 had 10 grinders requiring 2,250 horsepower each to run powered by a sluiceway canal that brought river water from the 1882 dam. A suspension bridge was also constructed linking the buildings on each side of the river. (Author's collection.)

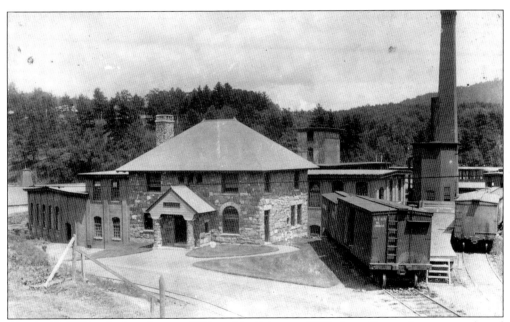

Charles T. Wilder died in August 1897, and by February 1899, the mill complex was purchased by International Paper Company. The company constructed this architecturally engaging stone office building the following year. The paper mill buildings and Lebanon, New Hampshire, hills are beyond. (Author's collection.)

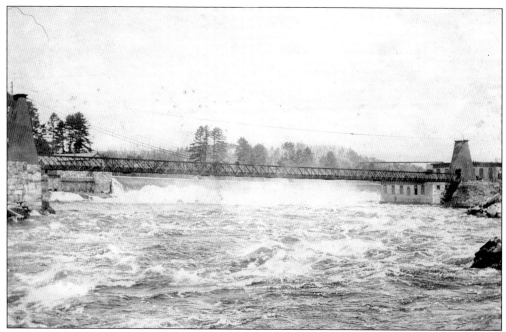

To link the pulp-grinding building located in New Hampshire with the mill complex on the left in Vermont, a steel and wood suspension bridge was constructed across the river in 1890. Narrow-gauge rail tracks allowed workers to push handcarts of fresh, wet pulp over to the mill for manufacture into paper. (Courtesy Hartford Historical Society.)

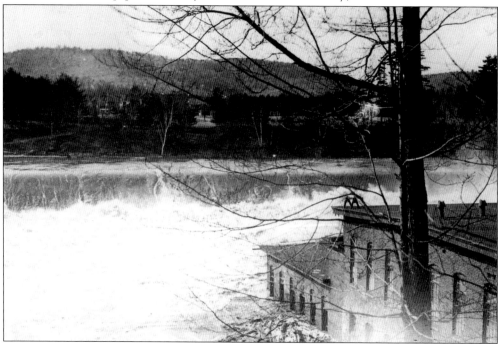

Although the March 1913 flood did not extensively damage the paper mill complex, it briefly inundated both the dam and pulp-grinding building, as seen in this view looking from the suspension bridge. Other areas of Hartford were not as fortunate. (Author's collection.)

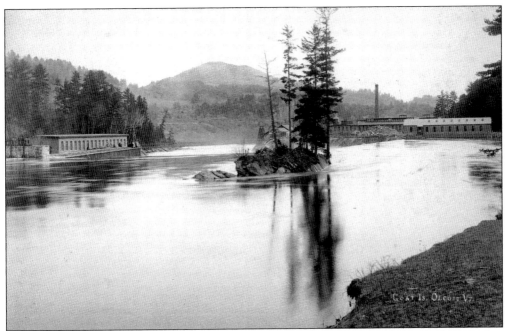

This image from about 1895 looking downriver makes for an interesting contrast with the earlier photograph shown on page 112. To the left in New Hampshire is the pulp-grinding building, and to the right in Vermont is the main mill complex. Goat Island is in the center middle ground. (Courtesy Hartford Historical Society.)

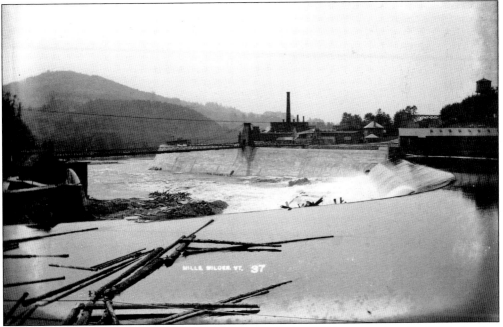

International Paper Company continued to expand the Wilder operation. In 1910, the first electrical generating equipment was installed, followed by additional units in 1912. Later during the same period, the old 1882 wooden crib dam was replaced by a new concrete structure. (Author's collection.)

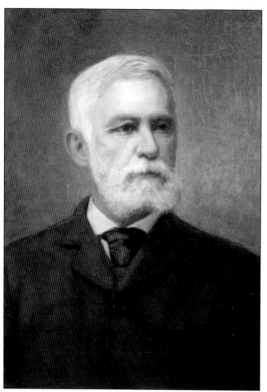

When Charles T. Wilder, born 1831, died in August 1897, he left no immediate heirs; however, he was generous in his will to Hartford, Dartmouth College, and others. One gift of $12,000 was for a bridge across the Connecticut River, as long as the Town of Hartford changed the village name of Olcott to Wilder, including the post office and railroad station. (Author's collection.)

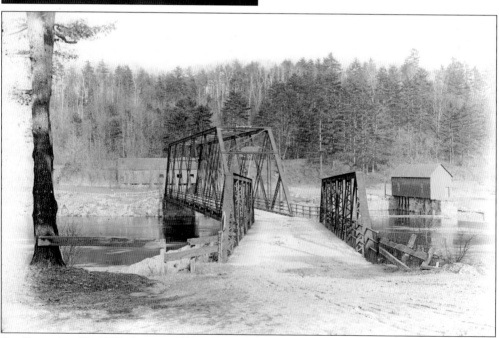

On December 10, 1897, the post office changed from Olcott to Wilder, and on March 4, 1898, at the annual Hartford town meeting, the voters approved both the new bridge and the name change. The bridge, located just above the paper mill dam and placed on Goat Island, is shown here about 1910 looking across to New Hampshire. (Author's collection.)

From 1869 through 1915, starting in the spring of each year, huge log drives came down the Connecticut River traveling as much as 230 miles, ending at sawmills in the Holyoke, Massachusetts, area. Because of the dam at Wilder, the drive was temporarily stopped to regroup before sending the mass of logs cascading over the dam and on their way southward. (Courtesy Hartford Historical Society.)

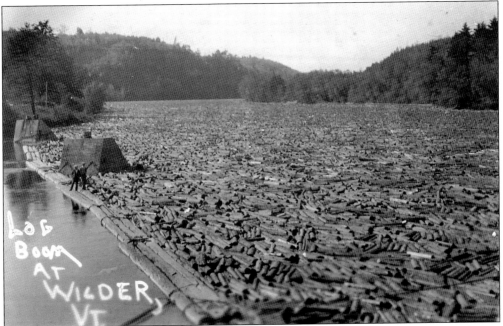

The last of the great Connecticut River log drives was in 1915. About 500 men with 40 horses on rafts used to free occasional jams pushed 65 million board feet of logs 230 miles downstream in about 170 days. Here is that drive temporarily halted at Wilder above the milldam. (Courtesy Hartford Historical Society.)

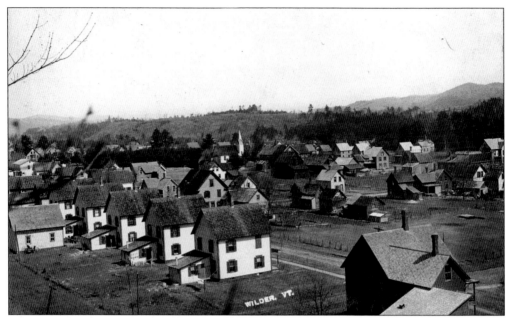

The establishment of paper mills by the Wilder brothers and their Olcott Falls Corporation in 1882 required workers and in turn necessitated housing. Soon a community of single-family homes and boardinghouses began to spring up on former farm fields adjacent to the mill complex. This image was taken about 1910. (Author's collection.)

Charles T. Wilder took an active interest in the planning and development of the new village. With the establishment of a new community of mill workers and their families came the need for commercial services and buildings. The village received a post office in 1887. (Courtesy Hartford Historical Society.)

In October 1888, the United Church of Christ in Olcott was organized, and on June 13, 1890, a new building was dedicated. S. S. Ordway and Company, who constructed the paper mill complex for the Wilder brothers, was the builder. When the village changed its name so too did the church. (Author's collection.)

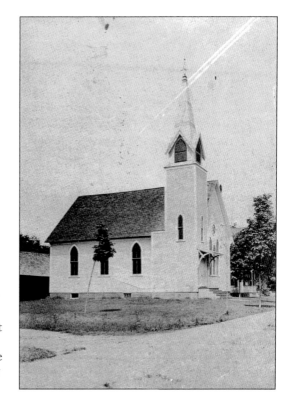

The Methodist Church was also quick to organize and build a facility in the rapidly growing village. Dedicated in April 1890, the Methodist Episcopal Church of Olcott in Wilder closed the building in 1923 and sold the property in 1931. With the steeple removed, it became a residence. (Courtesy Hartford Historical Society.)

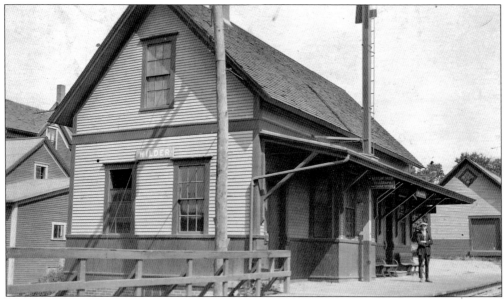

The Connecticut and Passumpsic Rivers Railroad, later part of the Boston and Maine Railroad system, established a passenger depot with freight facilities in Olcott in December 1885, 37 years after the rail line was first opened. The paper mill had its own siding. (Author's collection.)

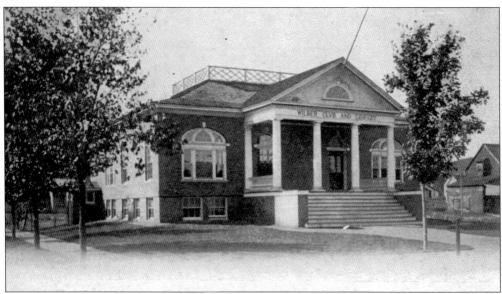

Charles T. Wilder also left $30,000 in his will to construct a village library with space for social gatherings. Almost two years after his death, this building was dedicated on June 14, 1899, with his brother Herbert L. Wilder and the president of Dartmouth College present. Charles T. Wilder was also very generous toward the college with the gift of a new physics building. (Author's collection.)

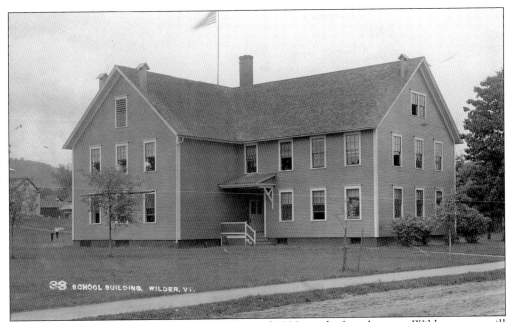

Prior to Olcott village being laid out in the mid-1880s and after the new Wilder paper mill complex began operation in 1883, there were no village or school facilities in this area of Hartford. This schoolhouse located on Norwich Avenue was quickly erected to serve the young and rapidly growing village. (Author's collection.)

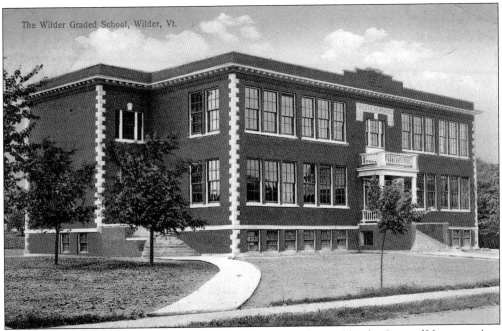

By 1912, the wood-framed village school building was condemned by the State of Vermont. As a result, this new masonry state-of-the-art school facility was completed in 1913. Also during this period within the town of Hartford, similarly substantial school buildings were constructed in White River Junction and Hartford Village. (Courtesy Hartford Historical Society.)

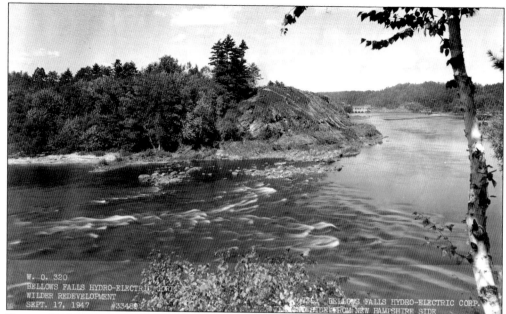

During 1927, International Paper Company permanently closed its mills in Wilder, although electrical power continued to be generated at the site. In the fall of 1947, when this photograph was taken of the Wilder Lower Falls, or Philips Bar, construction was soon to begin on a major new hydroelectric generating project. In the far distance is part of the old mill complex. (Author's collection.)

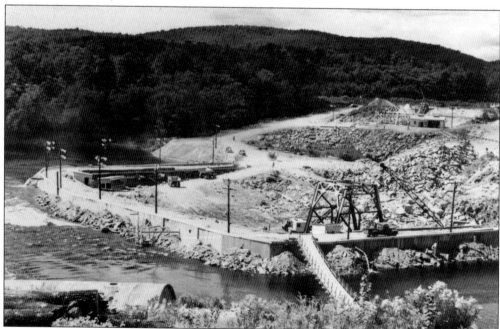

At the start of construction in 1948 of the new Wilder Dam, one of the first jobs was to construct a temporary cofferdam within the river adjacent to the Vermont bank. This view looks from New Hampshire. Soon after, foundations for the new dam abutments and powerhouse began to take shape. (Author's collection.)

124

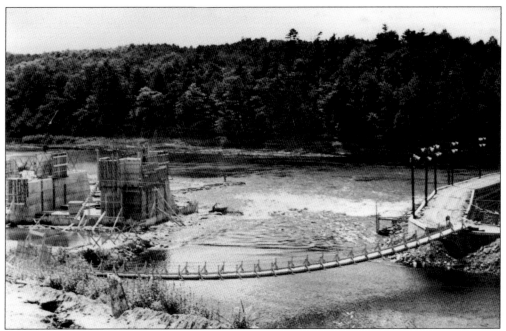

During 1948, as work progressed on the Vermont side of the river, concrete abutments for the four flashboard and two skimmer gate sections of the new dam were constructed on the New Hampshire side. When this image was taken looking downriver, the center of the great stream was still open. Note the temporary foot bridge. (Author's collection.)

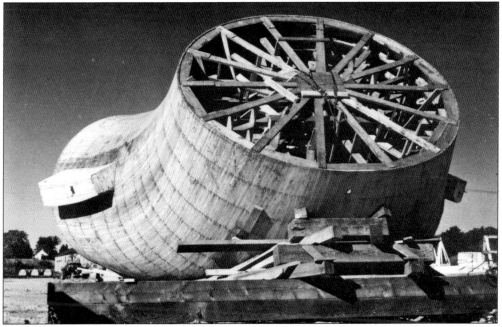

During the two-year construction period to build the new hydroelectric generating facility, more than 500 men at a time were employed on the site. One of the jobs required carpenters to construct temporary wooden forms for the two huge concrete draft tubes that would supply water to the two waterwheels, rated at 23,700 horsepower and 16,500 kilowatts each. (Author's collection.)

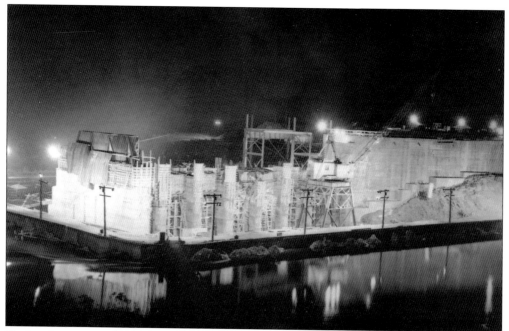

During the two-year-long construction period, work continued nonstop around the clock. The contractor was United Engineers and Constructors of Philadelphia, working with New England Power Service Company of Boston. This night view shows the new powerhouse portion of the facility under construction. (Author's collection.)

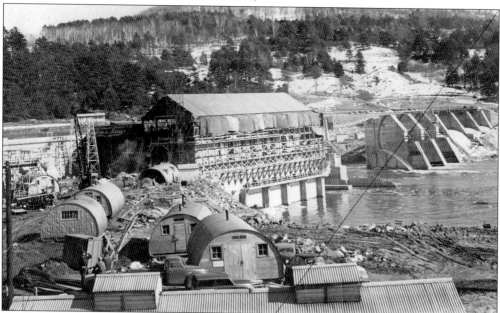

By the winter of 1950 when this view looking toward New Hampshire was made, the facility was mostly out of the water. The completed dam would have an earthen embankment 1,100 feet long, a concrete powerhouse, an intake section of the dam 200 feet long, a concrete spillway section 537 feet long, and a nonoverflow concrete section 205 feet long. (Courtesy Hartford Historical Society.)

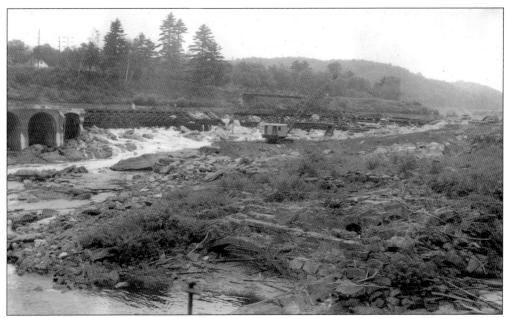

Between 1948 and 1950, as work progressed at the new dam site about three fourths of a mile downstream from the old Wilder paper mill facility, that complex was being razed, including the old dam structures. This 1950 view looks upriver from the New Hampshire site of the old pulp-grinding building. In the background is the Vermont section of the 1898 highway bridge and Goat Island. (Author's collection.)

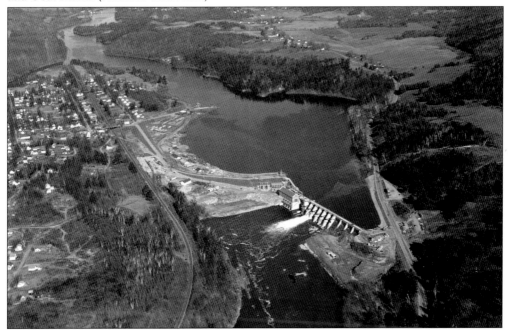

The new Wilder Hydro-Electric Generating Station was dedicated and put into full operation on November 29, 1950, when this view looking north up the river was made. The $16 million facility raised the river an additional 16 feet higher than the old dam, flooded 1,145 new acres in two states, and created a 46-mile-long pond. (Author's collection.)

ACROSS AMERICA, PEOPLE ARE DISCOVERING SOMETHING WONDERFUL. *THEIR HERITAGE.*

Arcadia Publishing is the leading local history publisher in the United States. With more than 3,000 titles in print and hundreds of new titles released every year, Arcadia has extensive specialized experience chronicling the history of communities and celebrating America's hidden stories, bringing to life the people, places, and events from the past. To discover the history of other communities across the nation, please visit:

www.arcadiapublishing.com

Customized search tools allow you to find regional history books about the town where you grew up, the cities where your friends and family live, the town where your parents met, or even that retirement spot you've been dreaming about.